SIXTIES SPOTTING DAYS
1968: THE LAST YEAR
OF STEAM

SIXTIES SPOTTING DAYS 1968: THE LAST YEAR OF STEAM

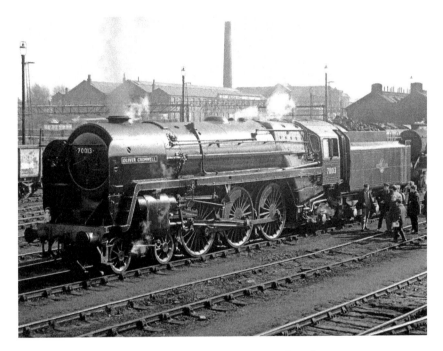

Kevin Derrick

AMBERLEY

This edition first published 2016

Amberley Publishing
The Hill, Stroud
Gloucestershire, GL5 4EP

www.amberley-books.com

Copyright © Kevin Derrick, 2016

The right of Kevin Derrick to be identified as
the Author of this work has been asserted in
accordance with the Copyrights, Designs and
Patents Act 1988.

ISBN 978 1 4456 6061 5 (print)
ISBN 978 1 4456 6062 2 (ebook)

British Library Cataloguing in Publication Data.
A catalogue record for this book is available from
the British Library.

Typesetting by Amberley Publishing.
Printed in the UK.

Contents

Introduction 6

Grim January Days 7

Freezing February 13

March Shedbashing Trips 19

April's Activity 29

May's Quickening Pace 40

Rays of Sunshine in June 49

Frantic July Spotting Days 55

Early August 67

1T57 79

Clear the Lines 84

Preservation Carries Us Forward 88

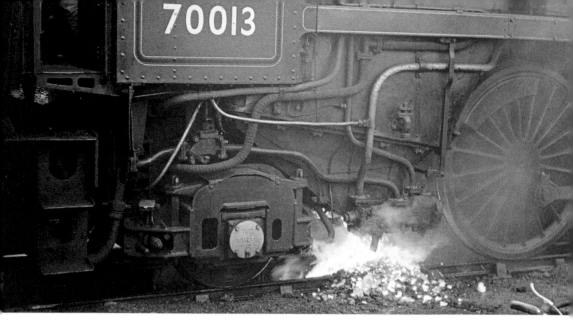

Fire dropping for Britannia 70013 *Oliver Cromwell* at Stockport Edgeley on 13 April 1968 with its day's work complete. (Jerry Beddows)

Introduction

Some readers will recall many of the events of 1968 with a great clarity, often because they were personally there, taking part in the visits and tours themselves and of an age to have been following the months as they went by in this last year of British Rail mainline steam. Your author was a young lad of ten at school in London, far away from all the action I was reading about each month in railway magazines, which were loaned by a kindly school master who shared an interest in trainspotting, as we used to proudly call our hobby back then.

What I have attempted to cover with a selection of photographs generously loaned by various contributors or from the Strathwood Library Collection, is a month by month recollection, interspersed sometimes with personal memories. If I had been a few years older I would have been in the thick of it, so to those who were I beg you to cherish your memories of this time of great change as you were very fortunate to have been part of it all.

Looking back with the aid of research, it is hard to believe just how many news events both on and off the railway come flooding back. Some feel like they were just yesterday while others a lifetime ago, before embarrassment and jibes from the popular media mocked our interests in railways with an attempt to win favour like a school bully during the eighties and nineties.

The last number one of 1968 would be that catchy number 'Lily the Pink' by The Scaffold. If like us you enjoy a little bit of nostalgia and cannot resist a good wallow again back in the Sixties then we hope you enjoy this and other volumes in the Spotting Days series.

Kevin Derrick
Boat of Garten 2009

Grim January Days

A cold start to the New Year at Salisbury, six months after the end of steam on the Southern Region, with the yard under a sprinkling of snow and still full of redundant steam locomotives making their melancholy way to South Wales scrap yards. This is Standard 5MT 73155, which had arrived here the previous July and would make its way behind a diesel to Cashmores of Newport, who would make commendably quick work of reducing an eleven-year-old locomotive back into seventy-six tons of processable scrap. An appropriate start to telling the story of the last year of British Railways' everyday steam perhaps and some of the highlights of 1968. (Michelle Howe)

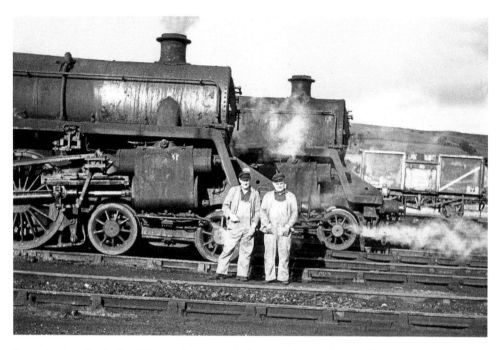

Steam bankers finished at Tebay at the very end of 1967, with even Clayton Type 1 diesels being tried as replacements in a bid to oust the Standard 4MTs. However, the shed closed on 1 January and some men took redundancy while others moved away from the railway in the following months. (Late Alan Marriott/Strathwood Library Collection)

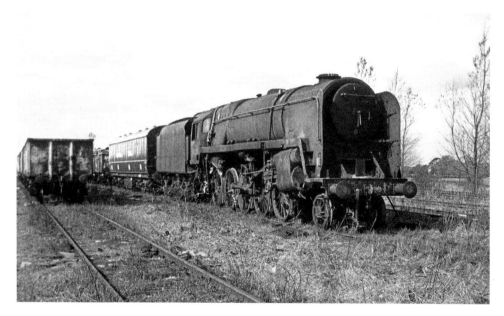

Crewe would continue to rid itself of stored steam engines such as Class 9F 92120, which was reduced quickly by Birds Commercial Motors at Long Marston along with other cast aside railway vehicles as the fashion for a modern image gathered pace. Promoted by the Labour government was the 'I'm Backing Britain' campaign encouraging workers to work extra hours without pay, or take other actions to help competitiveness spread throughout the country. (John Ferneyhough)

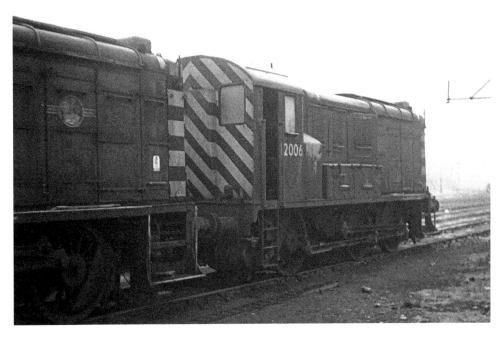

In this quest for modernisation even ex-LMS jackshaft drive diesel shunters such as No. 12006 had been withdrawn the previous September, as seen here at Springs Branch. It would be disposed of by Slag Reduction Co. at Ickles in June 1968. (Strathwood Library Collection)

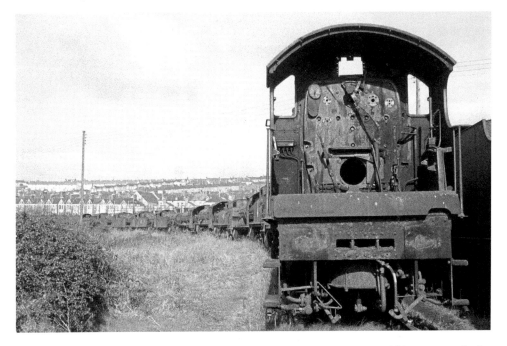

The importance to railway preservation of Woodhams Scrapyard at Barry would be recognised after 1968, as it just seemed back then they were too busy scrapping wagons to deal with the large store of locomotives. After all, there were many scrap yards across the UK gobbling up engines every day in 1968. (Win Wall/Strathwood Library Collection)

In the North West the dark satanic mills were still producing goods for sale, and workers could now commute to work in electric multiple units if they wished, such as this AM10 unit at Stockport. Also under the wires on Saturday 6 January, E3009 smashed into the stationary 100-ton transformer stalled on a road transporter on an automatic half barrier level crossing at Hixon. Eight passengers died on board the Manchester to Euston express, and three men on the locomotive, in this horrific crash. (John Green)

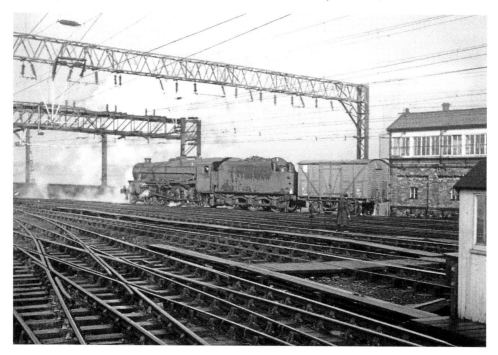

Even under a sea of catenary such as at Stockport, an enthusiast could still enjoy the smell of steam with this Black Five No. 44868 engaged in shunting off a van at the station. (John Gill)

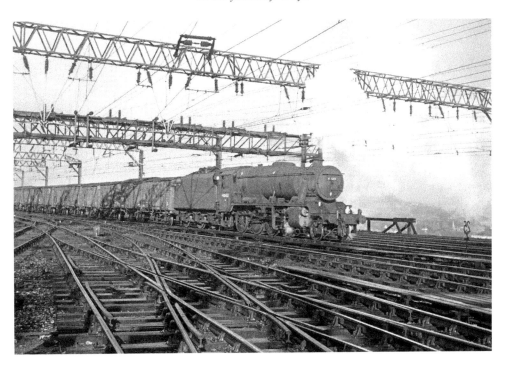

Stanier 8F 2-8-os were still very much active although their number of 150 at the start of the year was fast reducing month by month. Brighton-built No. 48683 would be laid aside the next month after being filmed passing through Stockport in January 1968. (John Gill)

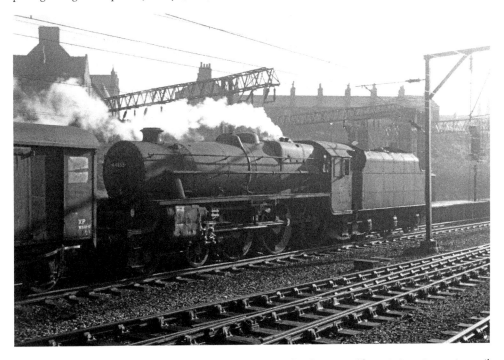

Crewe-built Black Five No. 44855, seen the same winter's day at Stockport, would remain in active service until May of 1968. (John Gill)

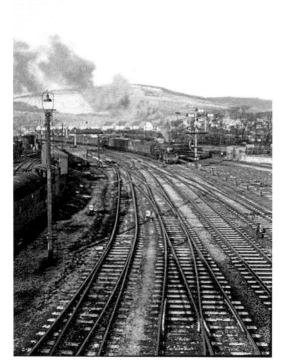

Left: Snow has dusted the ground at Carnforth during the month as we catch sight of an unknown Black Five halted at signals. Coming to an end during January would be the US television show *The Man from U.N.C.L.E.*, which was a big hit with many a schoolboy across the UK. (Strathwood Library Collection)

Below: One youngster is aboard Black Five No. 44781 at Bolton which would gain a last minute role as a film star in *The Virgin Soldiers*, only to perish rolled over in a ditch at Bartlow and be cut up on site when filming finished in December 1968. (Brian Hopkinson)

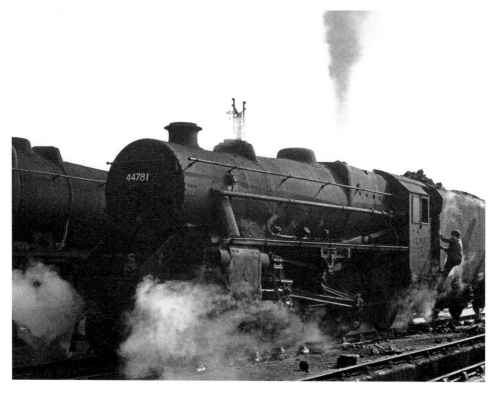

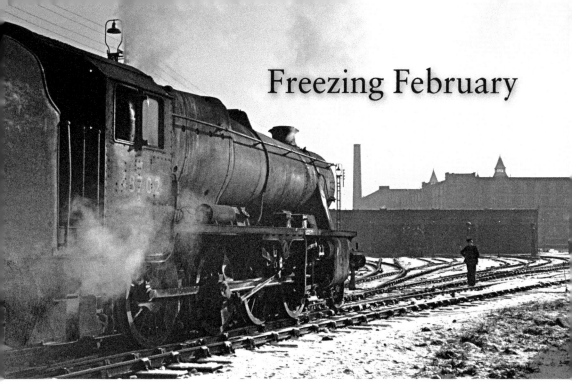

Freezing February

The month began with 'Everlasting Love' at number one from Love Affair with brisk sales from record shops. Railwaymen and enthusiasts were perhaps musing their own everlasting love for the steam engine as increased numbers took every chance to record the last days for posterity. One such cameraman was Dave Livesey, who lived close to Bolton at the time and photographed Class 8F 48702 coming on shed on 3 February. (Dave Livesey)

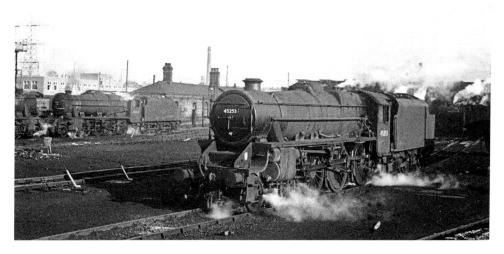

Over at Heaton Mersey the same day and not much snow, just sunshine to highlight Black Five No. 45253. Over in Kenya, things were boiling over and many Asians with British passports would flee to Great Britain during the month after the government in Nairobi set laws preventing them from finding work. (Strathwood Library Collection)

Also out of work were a number of stored AC and DC electric locomotives in the now closed locomotive shed at Bury. All of the ex-Woodhead route engines would be shipped to the Netherlands for further work or use as a source of spares. The AC locomotives, which had proved so troublesome on the newly 'modernised' WCML, would linger a little longer before being refurbished in the Seventies and put back to work. (John Ferneyhough)

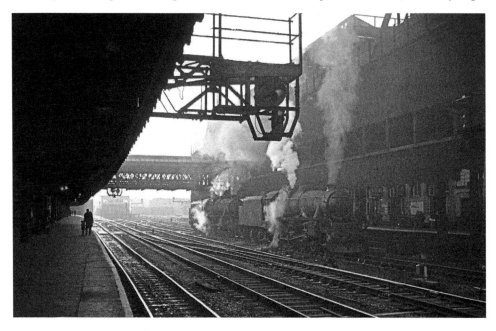

A father takes the opportunity to show a young lad a pair of Black Fives, Nos 44845 and 44884, at Manchester Victoria on 17 February 1968. A few days later and damages are to be awarded under a settlement agreed in the High Court to sixty-two children born with deformities, after their mothers took the drug Thalidomide during pregnancy. (Strathwood Library Collection)

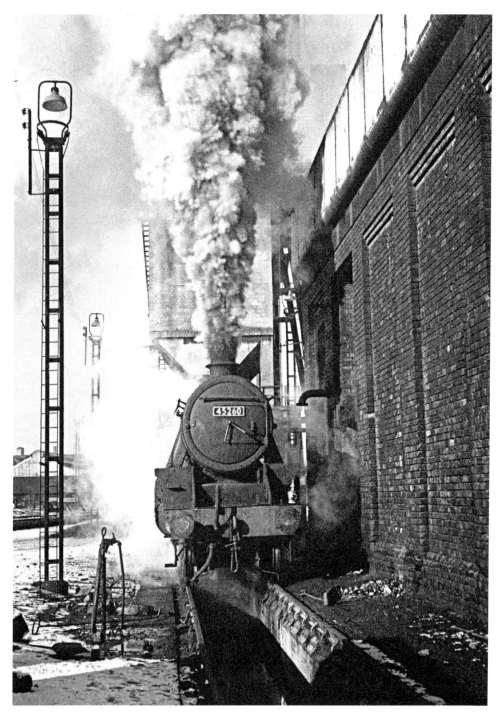

Over at Bolton the same day, our cameraman was on hand to watch Black Five No. 45260 slip violently as the crew moved her away from the coaler. Over in the United States there was growing unrest over civil rights with a number of deaths being reported during the month. This year was to experience further trouble everywhere from Vietnam and Czechoslovakia to Paris, as we would see. On a lighter note, one of the big films of the year in British cinemas at least was *Carry on up the Khyber*; echoes for the future perhaps? (Dave Livesey)

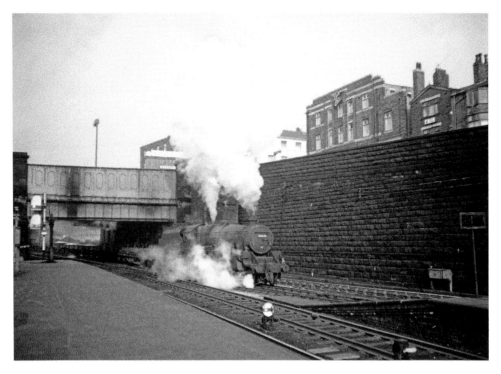

Rolling a permanent way train into Preston during the month was a Black Five. As so many turns were being carried out now by diesels, every chance to snatch a shot of working steam would be grabbed. (Chris Forrest)

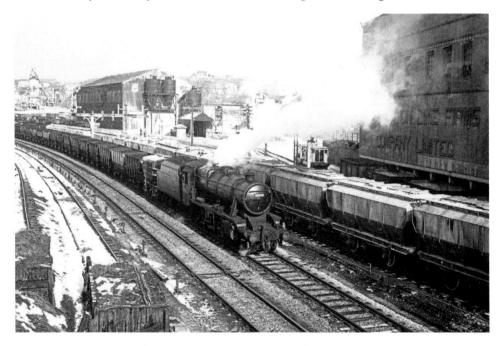

Many cameramen took the chance with February snows to record the last days of steam from Buxton shed and the Peak Forest line, such as here with Stanier 8F 48532. The route from Matlock to Peak Forest would close completely during the following July. (Strathwood Library Collection)

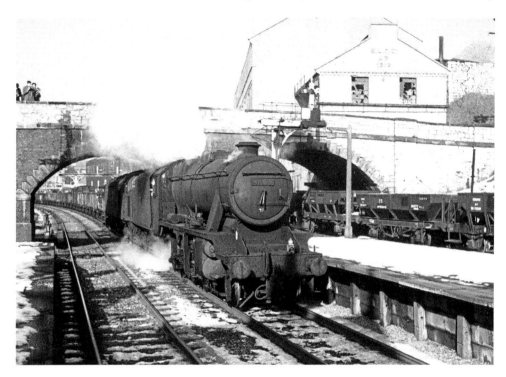

A small gathering is in place on the road overbridge as a Heaton Mersey-allocated Class 8F, 48365, pilots a named English Electric Type 4 on another freezing February day. (Strathwood Library Collection)

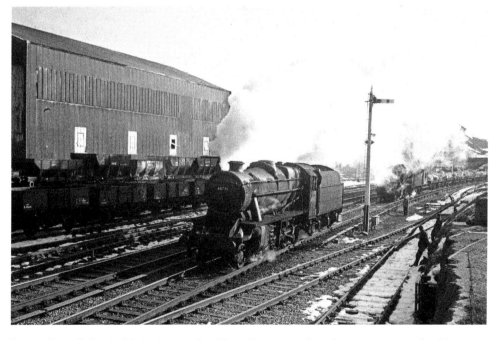

Being taken off after double heading another Class 8F is 48775 with its distinctive ex-army fitted larger top feed, again at Peak Forest. This engine was one of three that came into British Railways stock in 1957 from the Longmoor Military Railway. (Strathwood Library Collection)

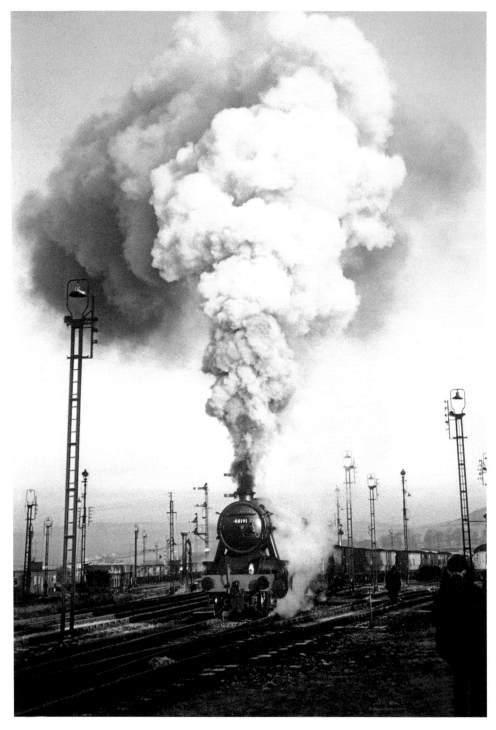

The roar of the exhaust from Stanier 8F 48191 would reverberate across Gowhole yard as the engine makes a spectacular getaway on 24 February 1968. At the beginning of this last year there were exactly 150 of her class in service. This one made it to August in service, before its ultimate demise at the hands of Wards at Beighton in Sheffield during December. (Dave Hill)

March Shedbashing Trips

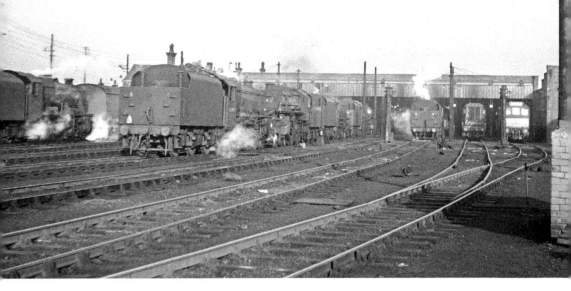

Many spotters made their pilgrimages to the last active steam sheds in the North West during the month, as here at Lostock Hall on 2 March. (Jerry Beddows)

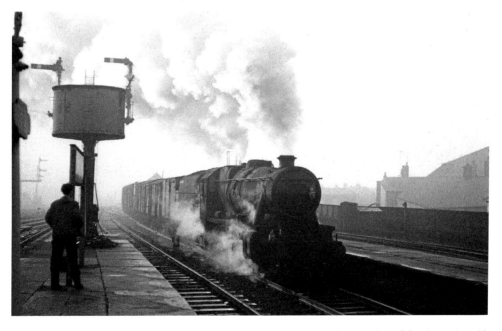

Passing nearby Blackburn during the same bash was Stanier 8F 48758 with an eastbound freight in the cold, crisp morning air. Whilst spotters were eagerly following their hobby, Wembley would host the League Cup Final on this Saturday afternoon, between Don Revie's Leeds United and Bertie Mee's Arsenal. The result would favour the Yorkshire supporters 1-0. (Jerry Beddows)

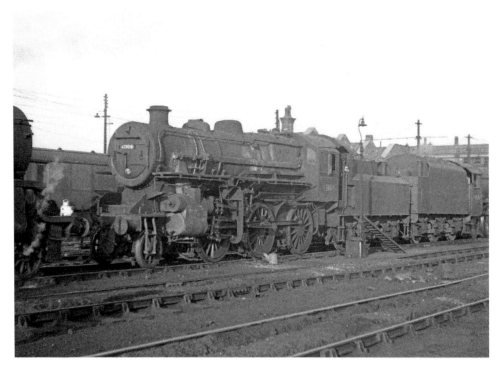

A place on the Severn Valley Railway and sanctuary in preservation would welcome this fortunate Ivatt Mogul No. 43106 being prepared at Lostock Hall during this same visit. (Jerry Beddows)

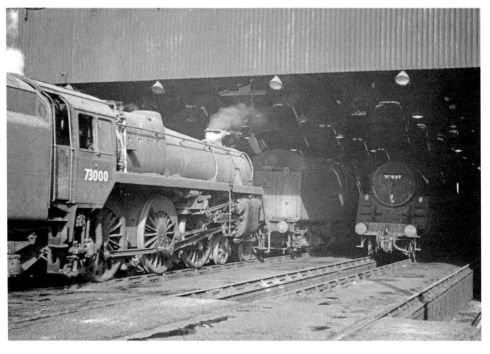

Over to Patricroft the next day to see what would be found on shed that Sunday, which included Standard 5MT 73000 along with a pair of classmates. (Jerry Beddows)

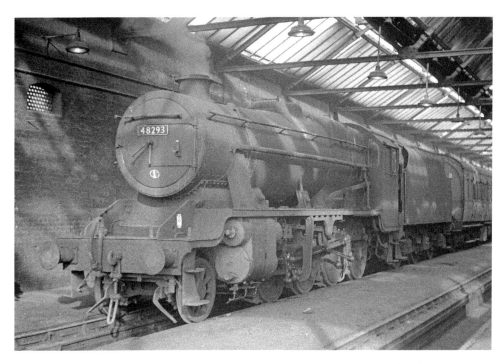

Many enthusiasts will have made such trips to cram in as many locations as they could, and our cameraman was no exception, recording Class 8F 48293 pleasantly light inside the sheds at Heaton Mersey on 3 March 1968. (Jerry Beddows)

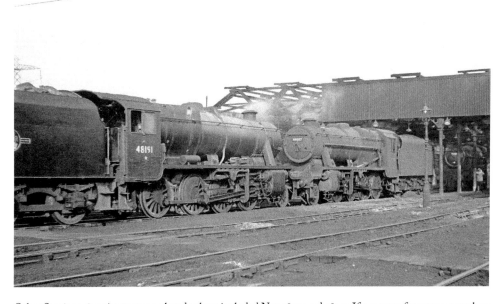

Other Stanier 2-8-0s in steam on that day here included Nos 48191 and 48327. If you were fortunate enough to be travelling in a car or van with a radio fitted you may have heard 'Cinderella Rockefella' by Esther and Abi Ofarim, or 'The Legend of Xanadu' by Dave Dee, Dozy, Beaky, Mick and Tich who would knock them off the top of the charts. (Jerry Beddows)

Arriving at Speke Junction on board a Commer van to a shed yard littered with dead locomotives, including Black Five No. 45232. The London and North Western Railway had established a locomotive depot here which became coded 8C by British Railways. (Jerry Beddows)

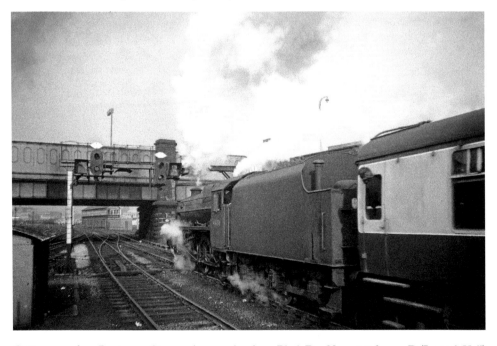

Getting away from Preston on this same busy weekend was Black Five No. 44816 from 10D (Lostock Hall) with, as might be expected at the time, an enthusiast hanging out of the front window of the train to enjoy the run while he could behind steam. (Jerry Beddows)

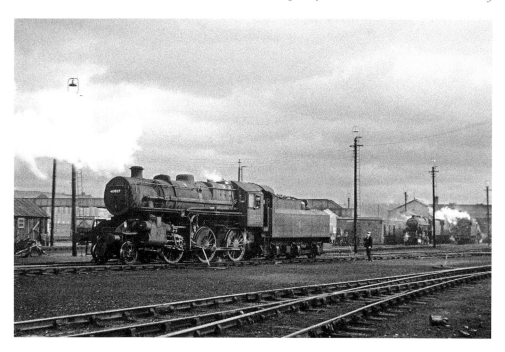

Back into the van for a run to Carnforth next and a busy shed yard there with Ivatt Mogul No. 43027 being repositioned within the depot by her crew. Steam would carry on at the depot thanks to preservation through the following decades, giving those less fortunate than to have made these shed bashes in the days of steam a sense of what it was all about. (Jerry Beddows)

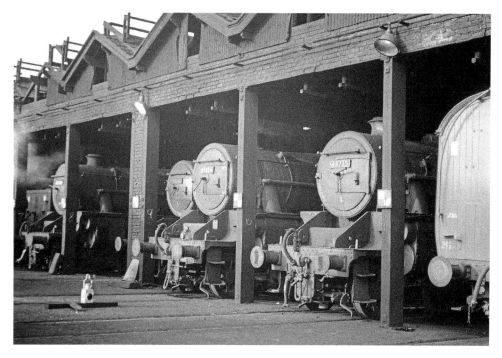

Drawn back again to the North West the following weekend on 9 March 1968 to get round Newton Heath and all of its sooty splendour, with Black Five No. 44735 among the many Stanier engines on shed today. (Jerry Beddows)

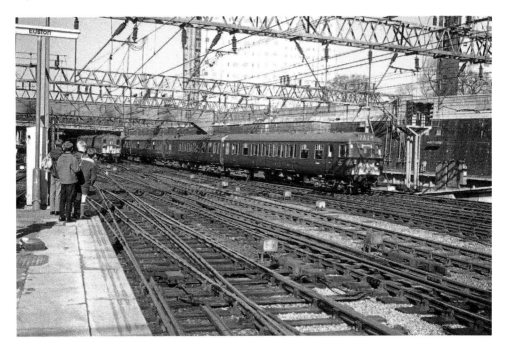

Many younger spotters who lived away from the North West were perhaps less fortunate to have been so active at this time, or perhaps it was beyond the bounds of their pocket money or parental permission. These young lads at Euston on 16 March 1968 record the details of a new AM10 unit and a London District set as they arrive. Not the same was it? (Frank Hornby)

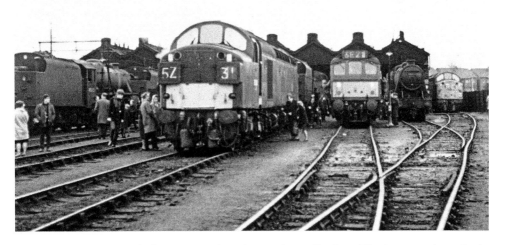

Spotters invade Stockport shed in some numbers the next day on Sunday 17 March 1968, with notebooks recording details of English Electric Type 4s and Sulzer Type 2s among the last resident steam engines at Edgeley (9B). (Strathwood Library Collection)

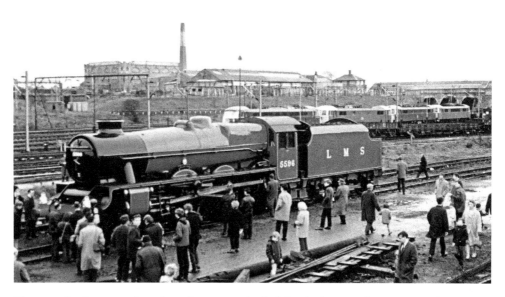

The reason for the increased numbers of spotters on the shed that day becomes clearer as we see the preserved Jubilee 5596 back on shed at Stockport after overhaul at Hunslet. Assorted WCML electrics are stabled closer to the mainline over the weekend. (Strathwood Library Collection)

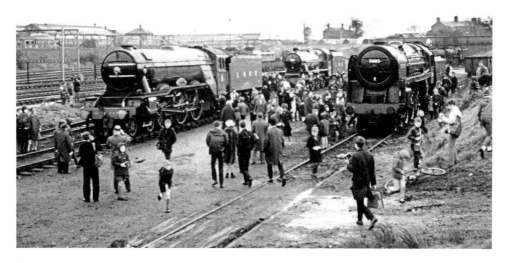

Also on display were *Flying Scotsman* along with Britannia Pacific No. 70013 *Oliver Cromwell*, which became British Railways' flagship steam locomotive for 1968. (Strathwood Library Collection)

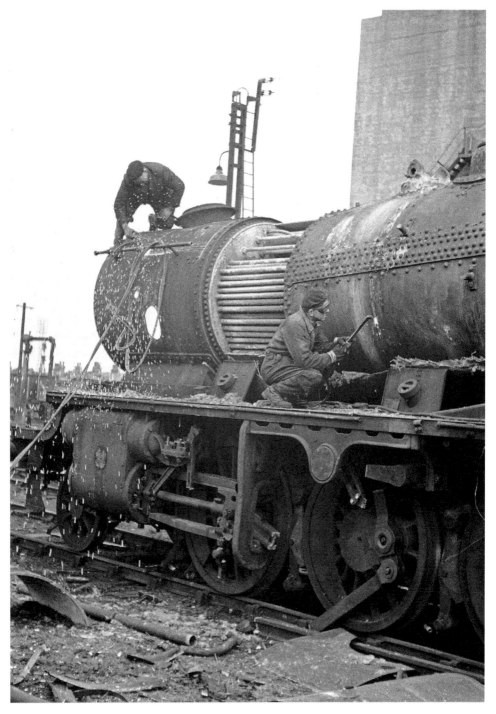

Health and safety fans eat your hearts out as the cutters get to grips with Stanier 8F 48469, which was deemed unfit to travel and was being cut up on the depot at Bolton on 30 March 1968. In the Oscars for this year were both Barbra Streisand for *Funny Girl* and Katherine Hepburn for her lead in *The Lion in Winter*. The judges could not pick a single winner so they both won for Leading Ladies, with the Best Picture going to Lionel Bart's *Oliver*. (Jerry Beddows)

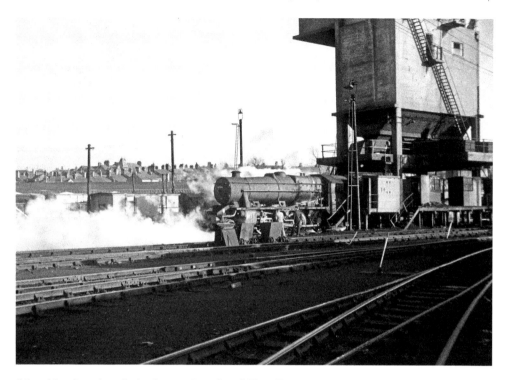

A long blast from the cylinder drain cocks on board Class 8F 48340 as she clears the coaler at Carnforth, also on 30 March 1968. (Strathwood Library collection)

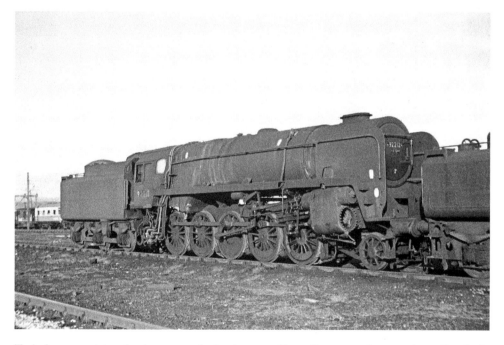

Tucked away awaiting that last run to the breakers was Class 9F 92212 on the same day at Carnforth. Fortunately, it would be to Woodhams of Barry and the locomotive would survive to preservation as a result. (Strathwood Library Collection)

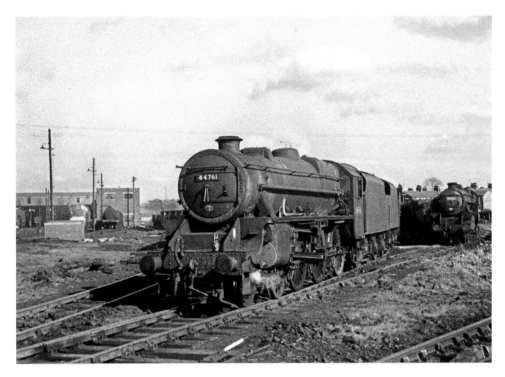

Shunting dead engines at Lostock Hall on this last weekend in March was Black Five No. 44761. Days later, it would be dumped here itself. (Strathwood Library Collection)

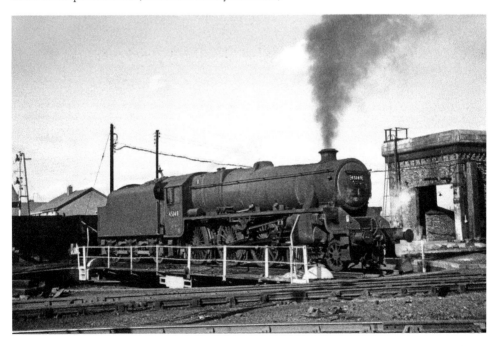

On its home shed of 10D (Lostock Hall), fellow Black Five No. 45149 would fare a little better, being withdrawn in June before joining the fast moving lines being broken up at Drapers in Hull, with cutting taking place in January 1969. (Strathwood Library Collection)

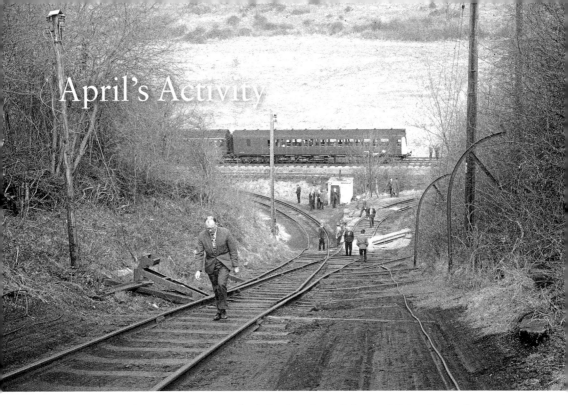

April's Activity

Among the first railways were those rope-hauled inclines beyond the capabilities of steam locomotives. Among these was Kilmersden Colliery Incline, seen here visited by members of the RCTS by DMU along the Radstock branch on 6 April 1968. (Frank Hornby)

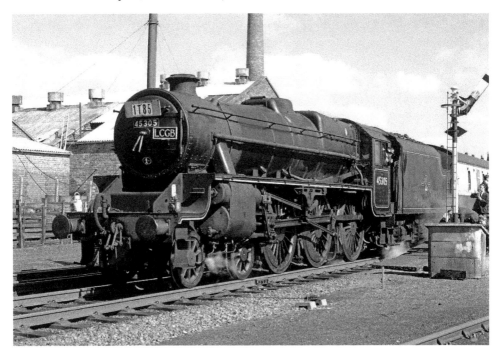

In charge of another tour train this weekend was Black Five No. 45305, which has paused at Burscough Bridge with the LCGB Lancastrian Railtour, also on 6 April. (Strathwood Library Collection)

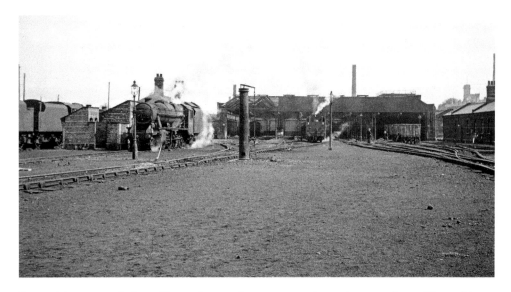

Repeat visits to steam sheds would mean fewer engines as every week went by now, as here at Heaton Mersey during April 1968. Sunday 7 April was a sad one for the motor racing world as it learned of the death of the gentleman driver Jim Clark. Hockenheim never was a circuit for the fainthearted. Its fast straights negated pure driving skill, turning races into flat-out slipstreaming epics in the days before chicanes were finally introduced to slow things down. Clark was eighth when he came round the stadium at the end of the fourth lap. He failed to appear next time around. The red, white and gold Lotus had spun at 160 mph on a gradual curve shortly after the first corner and crashed into the forest's unyielding trees, and in as much time as it takes to read these words, the world's greatest driver was killed. (John Gill)

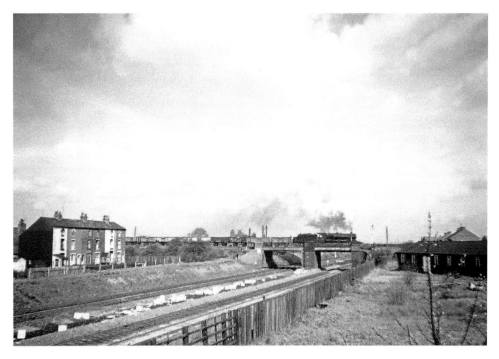

An unknown 8F catches the attention of our photographer on the Blackburn line at Lostock Hall on a lovely sunny spring day in April 1968. (Chris Forrest)

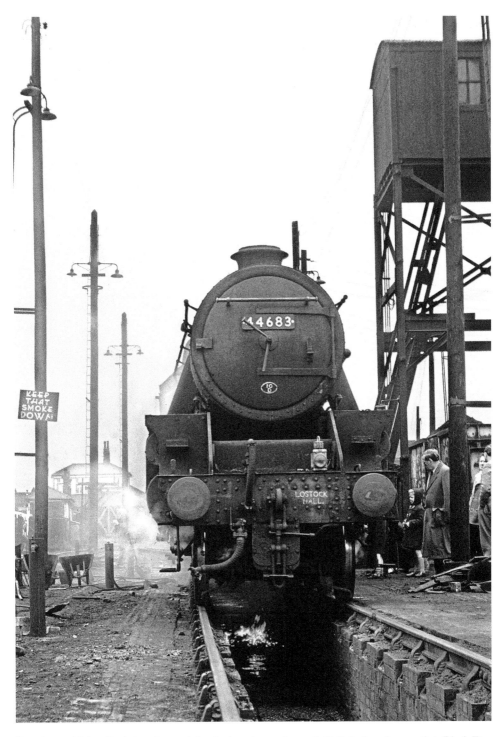

Seen here with her fire being dropped for the last time at Lostock Hall during the month is Black Five No. 44683. Legend suggests that when London Bridge was sold to American entrepreneur Robert P. McCulloch this month, he thought he was getting Tower Bridge instead. Undeterred he rebuilt London Bridge in the Arizona desert. And some think railway preservationists are crazy! (Win Wall/Strathwood Library Collection)

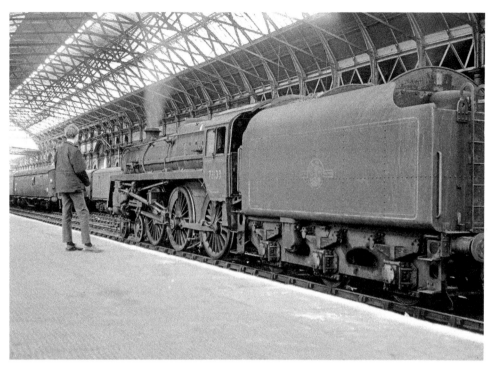

One young spotter with fashionable pointed-toe slip-on shoes takes a moment to enjoy Standard 5MT 73133 inside Manchester Exchange, April 1968. (Paul Godwin)

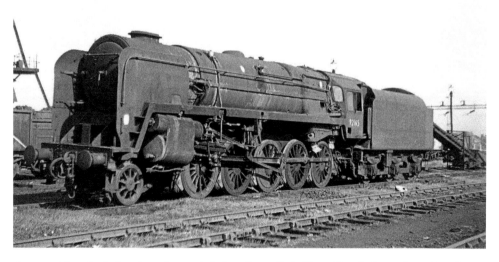

A return visit to Speke Junction a few weeks before closure finds Class 9F 92165 dumped, awaiting the trip to Cashmores of Newport the following month. This was one of three of her class fitted with Berkeley mechanical stokers in an attempt to improve engine performance beyond the abilities of a single fireman. (Strathwood Library Collection)

One enthusiastic chap supplies a little respect back to the last surviving named Black Five, No. 45156 *Ayrshire Yeomanry*, in the yard at Liverpool's Edge Hill. (Strathwood Library Collection)

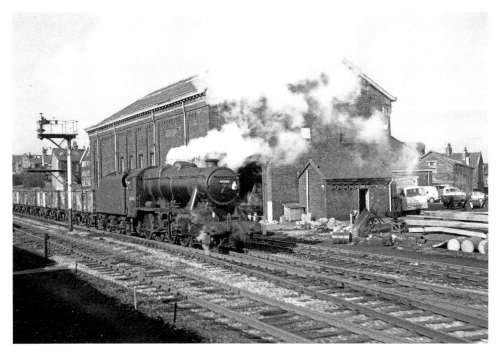

Pottering about with a short load of sixteen-ton mineral wagons at Lostock Hall was Class 8F 48340, someone having at least cleaned her up a bit a week or two before. (Strathwood Library Collection)

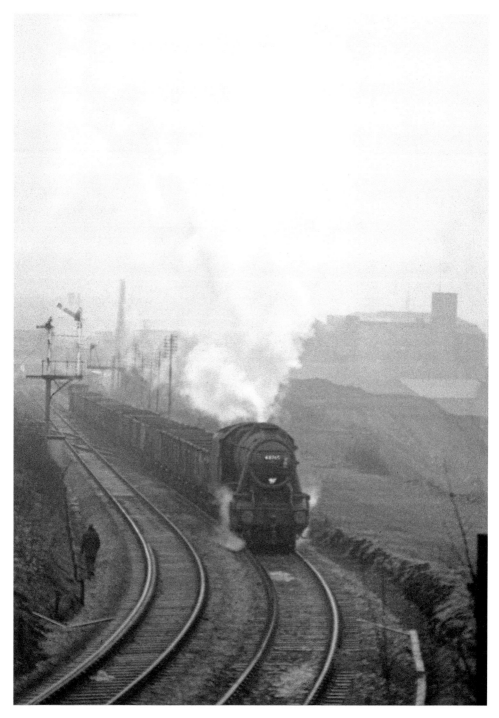

No high-visibility vest for the trackside on a misty 16 April 1968 at Bredhay as Stanier 8F 48765 keeps her train on the move into the tight curves here. A massive student rally in West Berlin had ended in violent clashes between police and protesters a few days before. The Berlin student unrest mirrored protests by young people around the world in 1968. In the US, young people demonstrated against the Vietnam war while in Paris students rioted over the 'bourgeois' university system and the 'police state'. (Jerry Beddows)

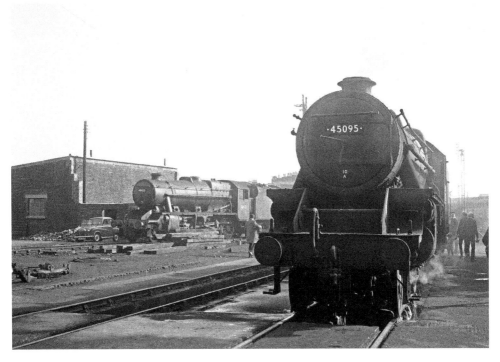

Much more peaceful in the shed yard as spotters wander about Lostock Hall, with a small child noting the numbers of Stanier locomotives Nos 45095 and 48423. (Win Wall/Strathwood Library Collection)

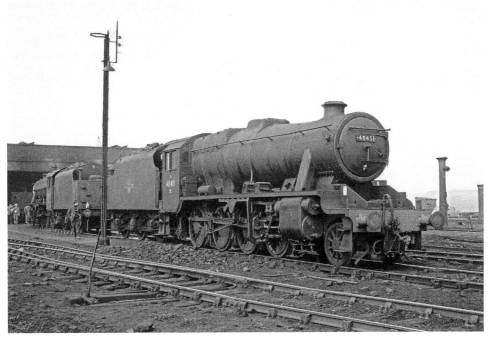

Another visitor saunters around 10D (Lostock Hall) with his hands in his pockets, not bothering with a notebook for Class 8F 48451. (Win Wall/Strathwood Library Collection)

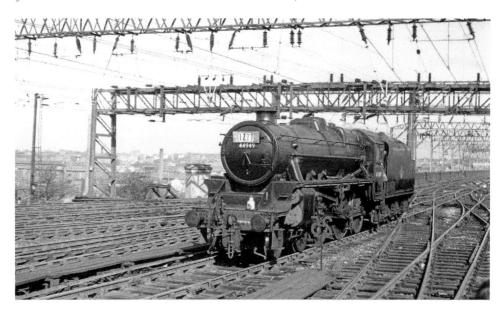

This was taken on the same day that Conservative right-winger Enoch Powell had made his hard-hitting 'Rivers of Blood' speech whilst addressing a Conservative association meeting in Birmingham. Mr Powell said Britain had to be mad to allow in 50,000 dependents of immigrants each year. He compared it to watching a nation busily engaged in heaping up its own funeral pyre, and enacting legislation such as the Race Relations Bill to 'throwing a match on to gunpowder'. He said that as he looked to the future he was filled with a sense of foreboding. 'Like the Romans, I seem to see the river Tiber foaming with much blood,' he said, estimating that by the year 2000 up to 7 million people – or one in ten of the population – would be of immigrant descent. Far less controversial was the appearance of Black Five No. 44949 at Stockport light engine on 20 April 1968. (Jerry Beddows)

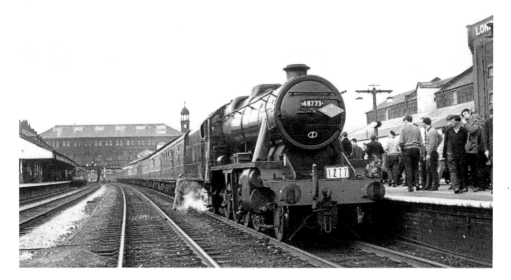

As part of the North West Tour run by the Manchester Rail Travel Society and the Severn Valley Railway Society, one leg was covered by Class 8F 48773, seen here at Bolton 20 April 1968. This 2-8-0 would be saved and runs today on the preserved line as a part result of the fundraising exploits of these foresighted society members. (Strathwood Library Collection)

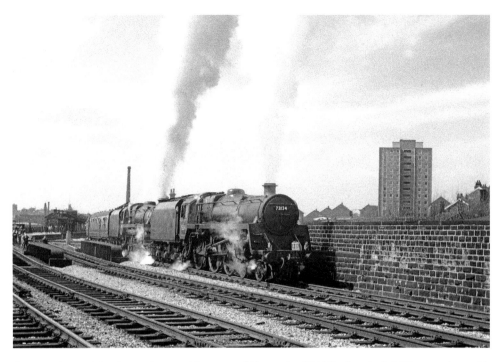

Among other participating engines on this tour would be a pair of Riddles Standard 5MTs, 73134 along with No. 73069 leaving Stalybridge on their way to Bolton and the engine change to pick up No. 48773, which we have already seen. (Jerry Beddows)

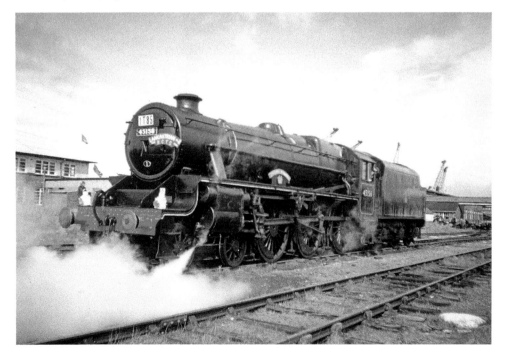

Meanwhile, RCTS members were on board another tour train in the area which involved a sparkling clean No. 45156 *Ayrshire Yeomanry*, which undertook several legs as seen here at Heysham. (Chris Forrest)

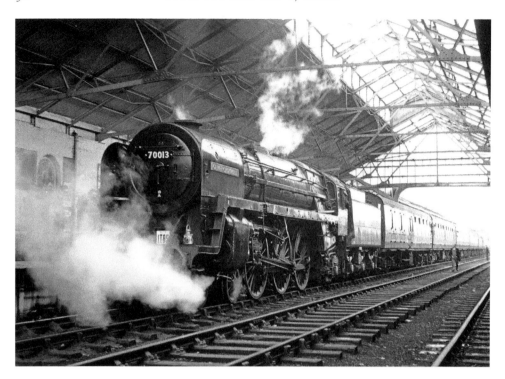

The main companion in this RCTS tour was Britannia No. 70013 *Oliver Cromwell*, under the overall roof at Windermere around lunchtime on 20 April 1968. (Stewart Blencowe Collection)

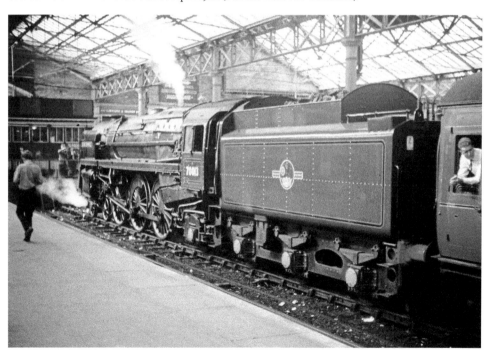

The following Sunday would see No. 70013 making another visit to Southport within a special train, this time with the GC Enterprises Tour, 28 April 1968. (Len Smith)

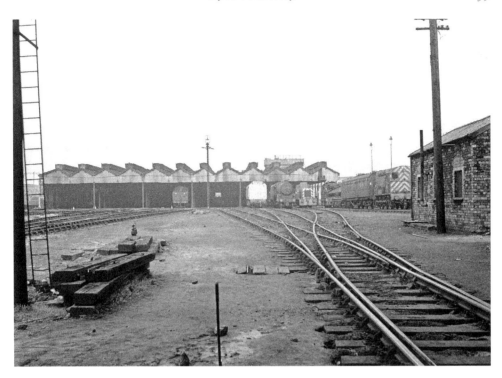

Once photographed by the celebrated Eric Treacy with Duchesses, Princesses, Scots and Jubilees, it must be said that Edge Hill was a little less than glamorous by 28 April 1968. (Paul Godwin)

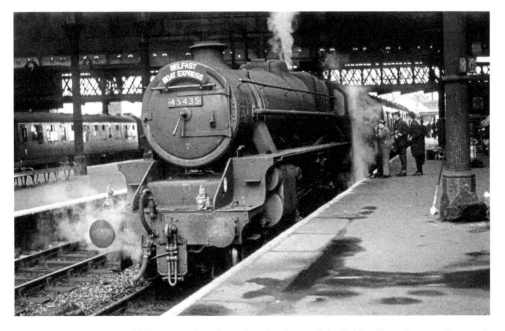

Some steam glamour would be retained to the end in the shape of the Belfast Boat Express, albeit with a once lowly and commonplace Black Five rostered for the turn. However, it was still a named train hauled by steam and on 28 April it enjoyed haulage behind No. 45435 when seen at Manchester Victoria. (Strathwood Library Collection)

May's Quickening Pace

Celebrating the fortieth anniversary of the first non-stop run from Kings Cross to Edinburgh, a much publicised special was arranged by Alan Pegler and the LCGB, leaving the capital at the famed time of 10.00 behind 4472 *Flying Scotsman* to arrive to a waiting crowd 392 miles away here at Waverley at 17.15, having just made it non-stop on 1 May 1968. (Strathwood Library Collection)

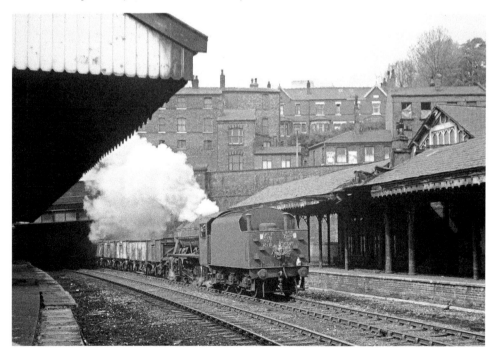

Less salubrious was the end of steam running through Stockport Tiviot Dale a few days later on 4 May, with a tender-first running of Class 8F 48356, suitably affixed with a wreath. (Jerry Beddows)

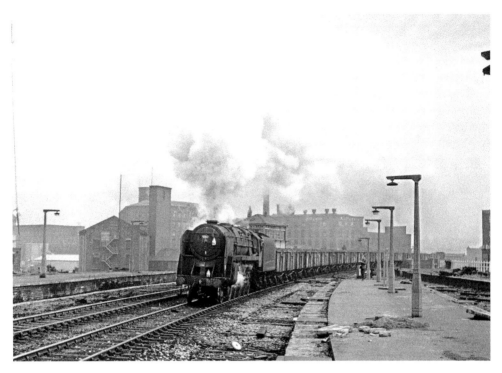

Witnessed running through the dilapidated station at Tiviot Dale during the day was Class 9F 92160, itself looking very shabby on this so-called modernised railway. (Jerry Beddows)

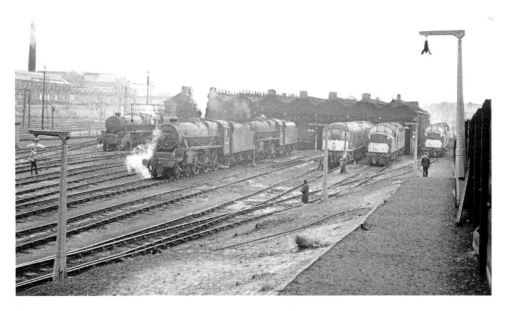

Several enthusiasts gather to take their photographs around Stockport Edgeley as the diesels increase in numbers on the depot again on 4 May 1968. (Jerry Beddows)

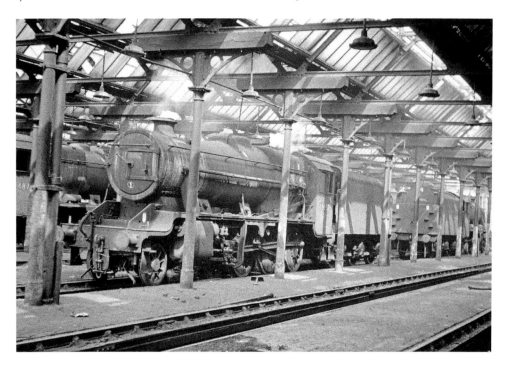

Smokebox number plates are now being sought after by collectors and many engines would end their days shorn of these embellishments, such as Stanier 8F 48687 inside the bright and airy locomotive shed at Heaton Mersey, also on 4 May 1968. (Jerry Beddows)

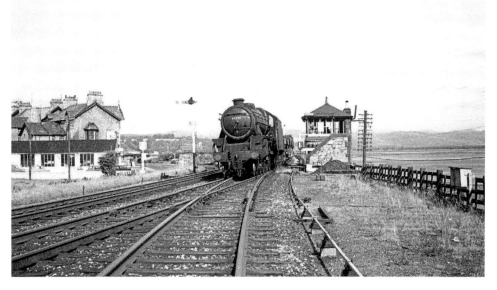

By the end of the week all the newspapers carried headlines telling of the infamous Kray Twins, 34-year-old Ronnie and Reggie, who were among eighteen men arrested in dawn raids across London. They would stand accused of a series of crimes including murder, fraud, blackmail and assault. Their 41-year-old brother Charlie Kray was one of the other men under arrest. Stark contrasts on the more peaceful Fylde coast as Armstrong Whitworth built Black Five No. 45231 rolls a goods past the stone based signal box at Arnside during the month. Preservation would be a saviour for this engine in a few more months. (Late Alan Marriott/Strathwood Library Collection)

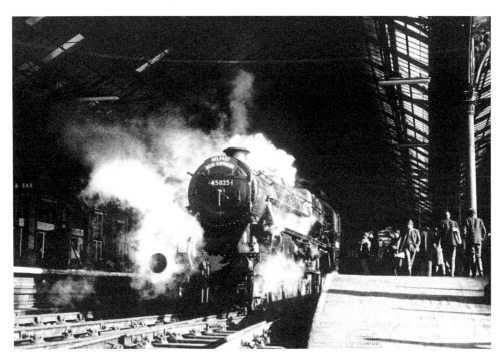

The preservation movement would also save what is today the oldest surviving Black Five, No. 45025 on the Strathspey Railway. Enthusiasts would gather for her departure on the last Belfast Boat Express on 5 May from Preston, which was the 06.15 Heysham Harbour to Manchester Victoria. (Dave Hill)

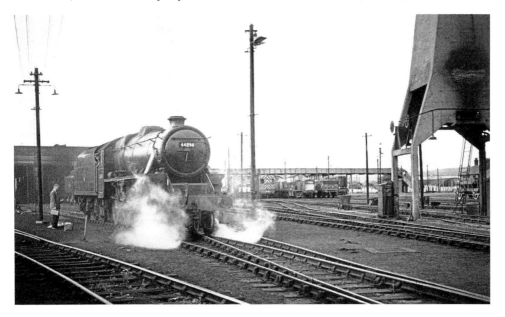

Sound recording was also a pastime for many with the equipment in the final years. Although it should be remembered that the equipment was not as lightweight as the widely available cassette recorders of the early seventies. One who made such recordings with friends was Alan Marriott, who had been at work with his equipment before breaking off to get this photograph of Black Five No. 44894 in the shed yard at Carnforth. (Late Alan Marriot/Strathwood Library Collection)

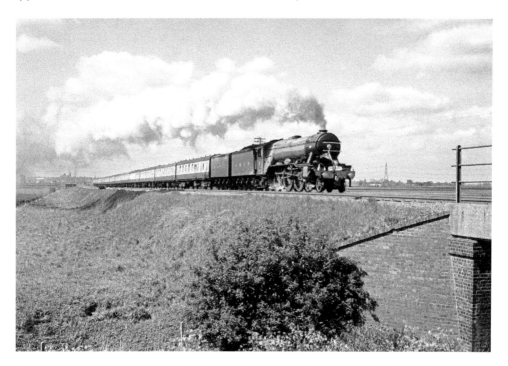

Sporting the second tender, 4472 *Flying Scotsman* brings steam alive again in East Anglia for the day on 12 May, running well at Prickwillows with an Anglo Norse Society Special which ran from Kings Cross via Hitchin, Cambridge, and Ely to Norwich and back. (Jack Hodgkinson)

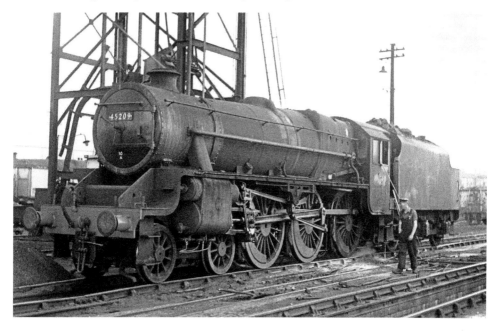

Being prepared for duty at Carnforth in its penultimate month in traffic was Black Five No. 45209. A long-time resident of the North West, spending many years based at 24B (Rose Grove) before one final move to 10A (Carnforth) in April 1964, she would join so many of her type at Drapers scrap yard in Hull in the end. (Michelle Howe)

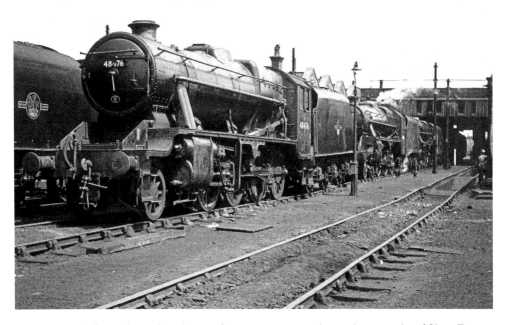

A few noticeable dips in the track work give a droopy appearance to the coupling to tender of Class 8F 48476, with evidence of enthusiasts cleaning many engines to enhance their photographs around Lostock Hall by May 1968. (Late Alan Marriott/Strathwood Library Collection)

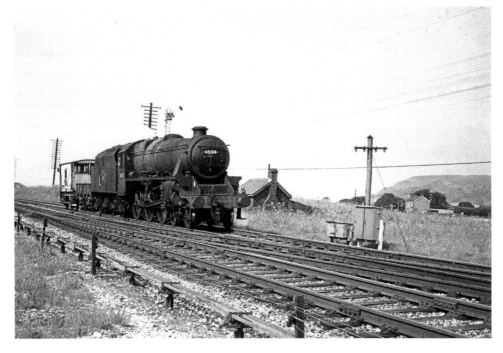

Hardly a taxing duty for this combined dome and top feed-fitted Black Five, No. 45134, ambling along in the warm sun near Milnthorpe. (Late Alan Marriott/Strathwood Library Collection)

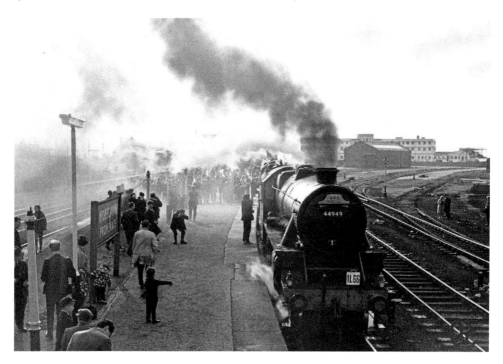

Another duty on an enthusiasts' special for Black Five No. 44949 having arrived at Morecambe, to the amazement of this young child, with the Warwickshire Railway Society North Western Steam Tour on 18 May 1968. (John Green)

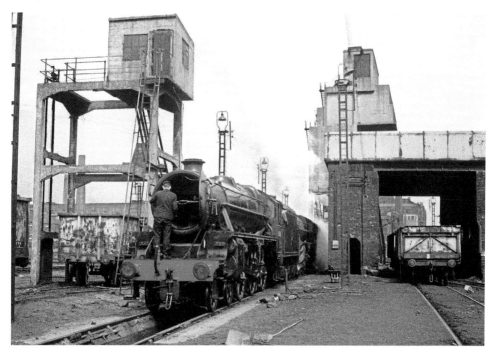

Another clean Stanier Black Five gains a little attention inside the smoke box whilst at Bolton; another makes some fuss behind in the coal road. (Dave Livesey)

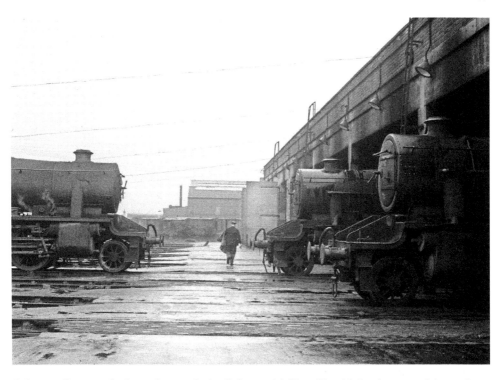

A driver walks across the front of a quiet shed at Bolton with lifeless 8Fs stabled under cover whilst another is in steam outside in the rain. (Dave Livesey)

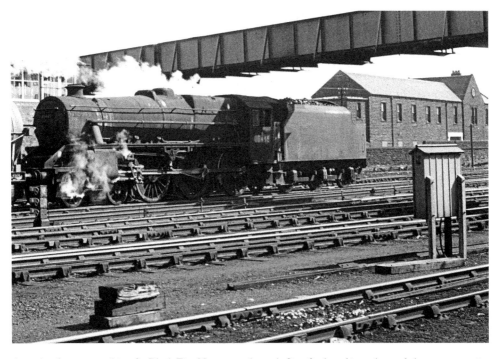

A tender-first trip working for Black Five No. 45445, through Carnforth and into the yards here on a sunnier day in May. (Strathwood Library Collection)

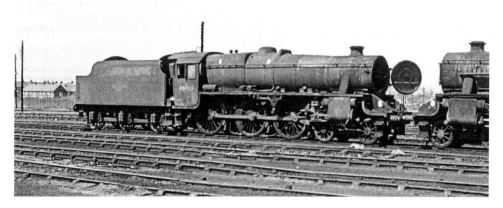

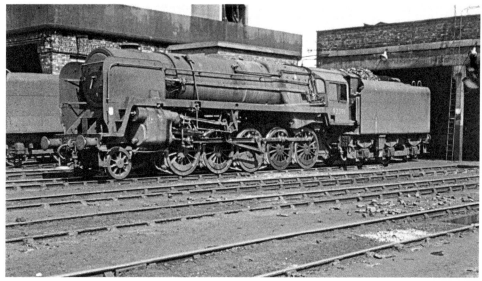

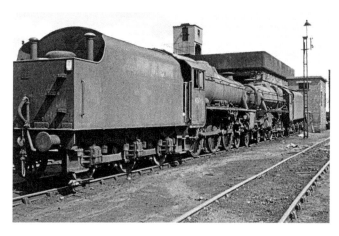

A selection of photographs
taken after the closure of 8C
(Speke Junction) on 5 May
leaves Black Five No. 45007
and Class 9F 92091 standing in
the quietness where birdsong
could be heard once more now
that the sounds of the steam
age had ended here for good.
(Strathwood Library Collection)

Rays of Sunshine in June

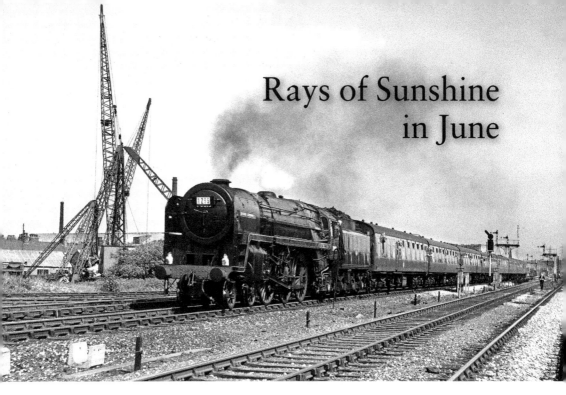

On the first day of the month British Rail Scottish Region ran their Grand Rail Tour No. 5 from Edinburgh Waverley, setting out just before 08.00 behind D1773 as far as Carnforth, where No. 70013 *Oliver Cromwell* took over for the run onwards to Guide Bridge, where we catch the train at Miles Platting. Next for the passengers was a run through the Woodhead Tunnel to Sheffield Victoria and back behind E26052 *Nestor*, handing back to the Britannia after it was serviced at Newton Heath for the onward journey back north to Hellifield. Here D1773 would resume haulage as far as Stirling, handing the baton over for the last leg back to Waverley twenty-two minutes down at 22.44. (Both Photographs Jerry Beddows)

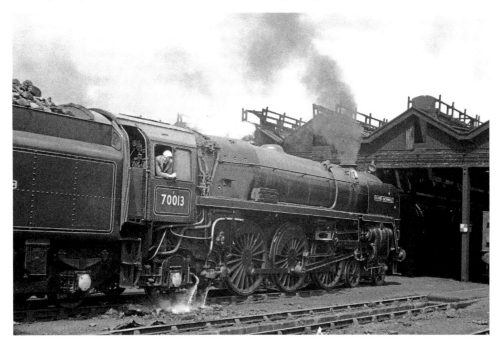

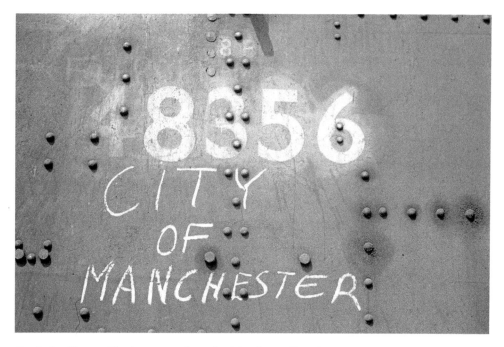

On shed at Newton Heath, just two days after Manchester United became the first English winners of the European Cup after beating Benfica 4-1 in extra time at Wembley Stadium, was this timely chalked inscription on Stanier 8F 48356. Duchess No. 46246 *City of Manchester* had been scrapped exactly five years before. (Jerry Beddows)

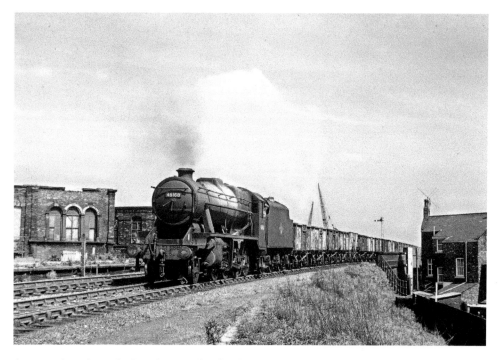

A session along the trackside in those carefree days brings us another 8F, with No. 48168 dropping down the bank at Miles Platting on 1 June 1968. (Jerry Beddows)

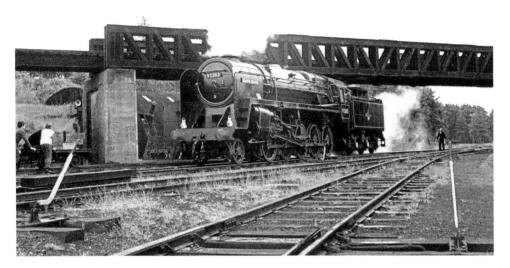

It was on 7 April that both Nos 75029 and 92203 came south to Longmoor, where we catch up with David Shepherd's 9F in steam on 8 June. They ran as far as Liss under their own steam, breaking the steam ban in place at the time. Both engines were held up for an hour on their journey at Acton Wells Junction as the signalman had forgotten to take up his duties to set the road at Kew Bridge Junction. (John Green)

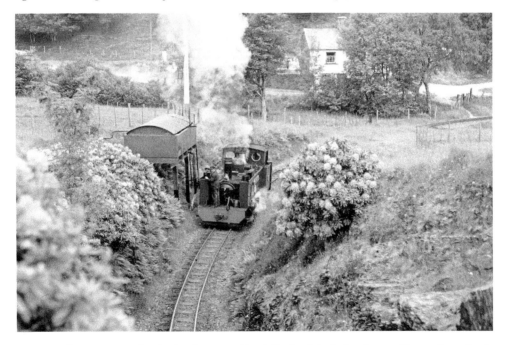

The rhododendrons gave a fine display that year at Devils Bridge. It looked at the time like number 7 *Owain Glydwr* and the two other engines on the Vale of Rheidol lines would be all that would survive the impending total steam ban on British Railways during this visit on 19 June. (Aldo Delicata)

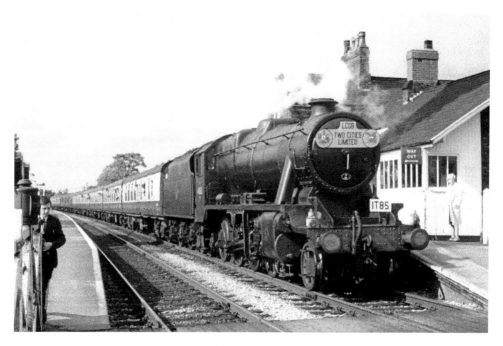

As the summer progressed, steam specials would be run every weekend to take every opportunity of catching what steam runs could be made. Taking a circular route between Liverpool and Manchester on 23 June would be Standard 5MT 73069, sharing turns with Class 8F 48033 which was caught on camera at Mobberley. (Strathwood Library Collection)

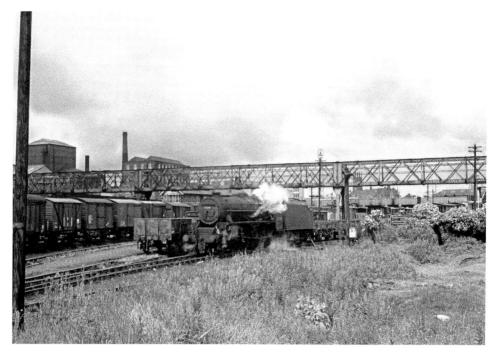

The lupins are blooming well on the poor soil during a visit around noon to watch Black Five No. 45390 shunt at Lever Street Sidings at Bolton on 28 June, with closure of Bolton depot only days away now. (Dave Livesey)

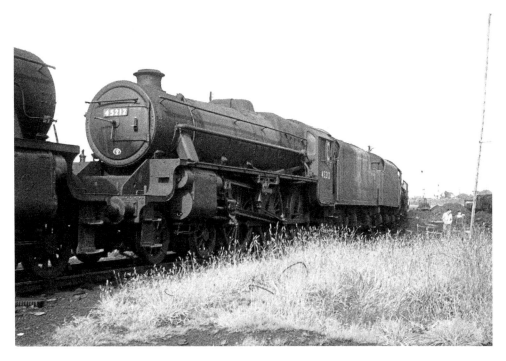

This lucky Black Five, No. 45212, would be plucked from the lines of doomed locomotives in this visit to Lostock Hall on 29 June as she would be shown as withdrawn in August and would pass to eager preservationists who refused to see steam die completely. (Strathwood Library Collection)

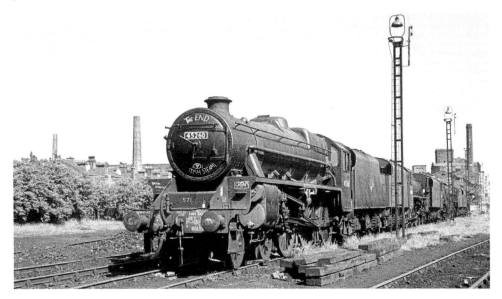

The lines of cold engines would attract many to record them with their cameras, some engines carrying fondly written chalked inscriptions, like sentiments upon tombstones, as applied to No. 45260, dumped at Bolton on the last day of the month. Much was also written earlier in the month about the shooting dead of Robert Kennedy in a Los Angeles hotel lobby, the very able younger brother of President John Kennedy who was assassinated in 1963 as he travelled in an open-top car in Dallas. Perhaps the USA would have had another Kennedy in the White House had his assassin failed. (Strathwood Library Collection)

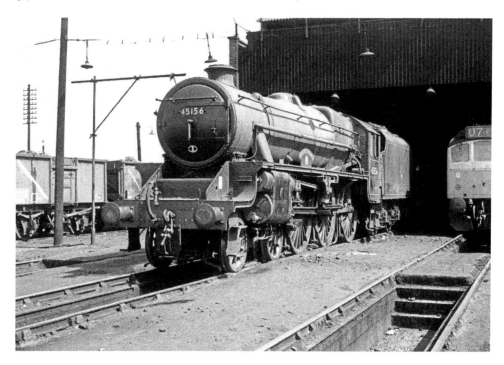

Scruffier than when last seen on 20 April is Black Five No. 45156 *Ayrshire Yeomanry*, bearing just painted smoke box number, nameplate and crest between duties at Patricroft on 30 June. The next day the ex-LNWR engine shed here would be posted as closed. (Strathwood Library Collection)

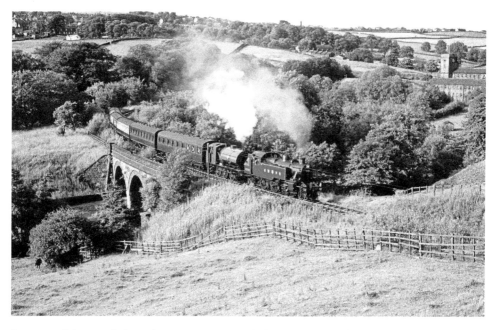

It was not all doom and gloom that summer as across the Pennines the Keighley and Worth Valley Railway were growing from strength to strength with enthusiastic volunteers running trains such as this combination utilising Ivatt 2MT 41241, which had been withdrawn from regular British Railways use in December 1966. (Trans Pennine Publishing)

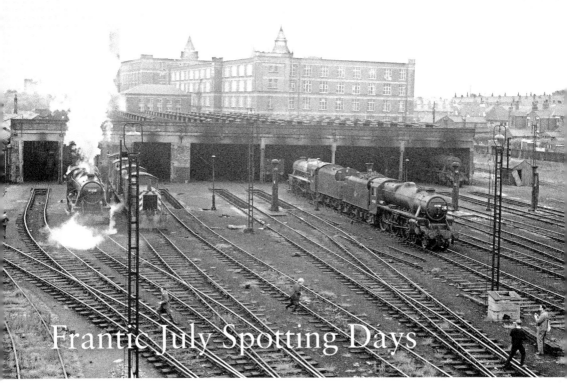

Frantic July Spotting Days

The final day at Bolton would be 1 July, with enthusiasts on hand to see engines make their way off shed for the last time. The four Drewry diesel shunters were already withdrawn from service. This ex-Lancashire and Yorkshire Railway engine shed had just three years earlier enjoyed fifty-seven steam locomotives allocated to its books. (Both Photographs Dave Livesey)

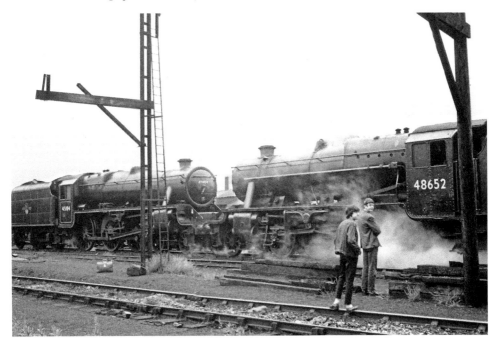

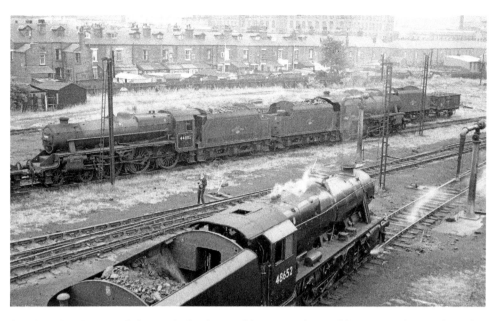

Seen from the ash tower at Bolton on this last day were Nos 48652 and 44802. More engines than usual would be on engine sheds across the country at that time as the country's rail network had been thrown into disarray by the National Union of Railwaymen's (NUR) work-to-rule. The chaos became worse as the week progressed as more than 20 per cent of railway work was carried out on overtime. Barbara Castle, Secretary for Employment and Productivity, made it clear that the government would not intervene in this latest dispute. On Friday 5 July 1968 the work-to-rule was called off after the NUR accepted a peace offer from British Rail. (Dave Livesey)

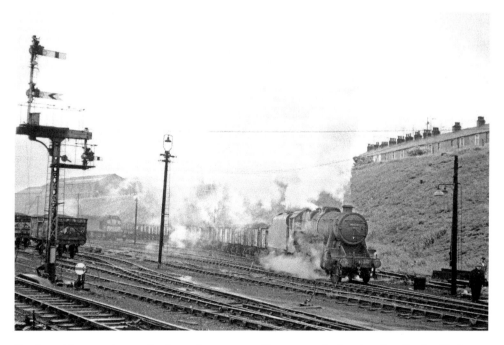

For those able to get about at the time, a few steam workings were to be found, such as Stanier 8F 48730 at Rose Grove on 3 July 1968. The Associated Society of Locomotive Engineers and Firemen (ASLEF) also joined the dispute, which inevitably caused further cancellations and delays. (Jerry Beddows)

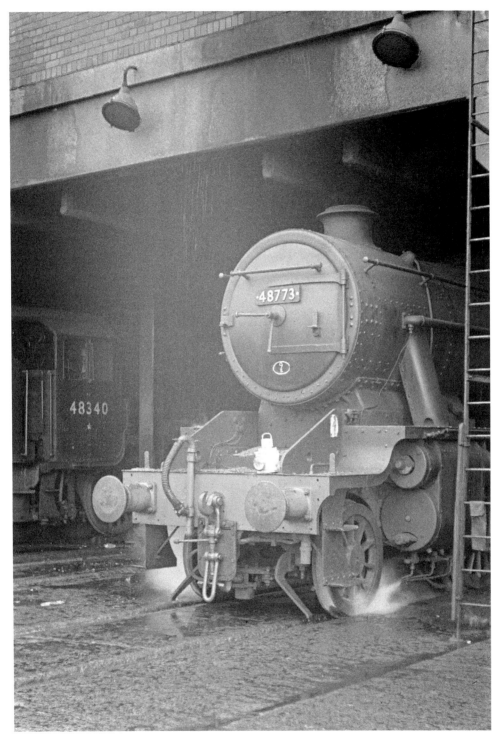

Persistent rain would also hamper the efforts of many photographers with slow films. However, our cameraman's efforts were rewarded with this study of Class 8F 48773 in a very wet Rose Grove on 3 July 1968. (Jerry Beddows)

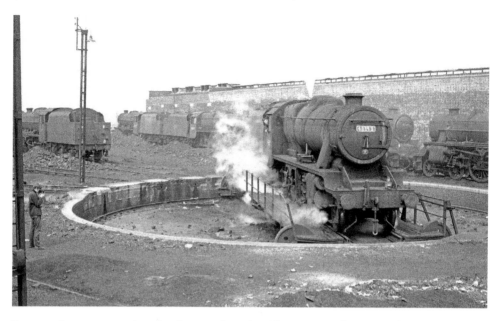

Just one other cameraman is on hand to record another 8F 2-8-0, 48393, being turned at Rose Grove the next day. However, a crowd of more than 250,000 people had gathered to congratulate the Portsmouth greengrocer Alec Rose on his 28,500-mile solo trip around the globe as he received a hero's welcome sailing back into Portsmouth after his 354-day voyage. The same day, the 59-year-old was escorted into Portsmouth harbour by 400 motor-boats, yachts, catamarans and canoes blowing sirens and whistles. (Dave Livesey)

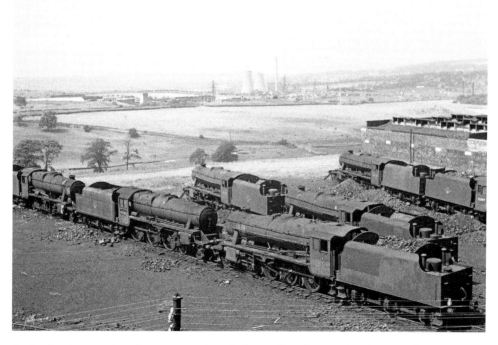

Stocks of engines awaiting sale to scrap merchants built up at Rose Grove, as they did at all of the North West engine sheds during these summer months. (Jerry Beddows)

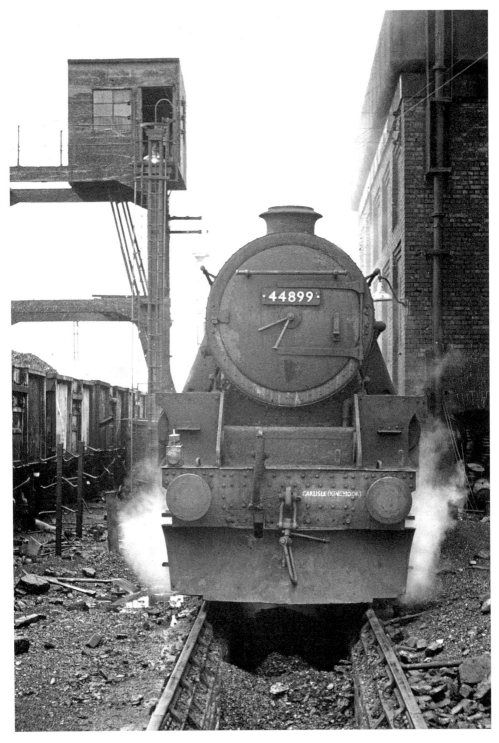

No need to remove the snow plough from Black Five No. 44899, standing again in the rain at Rose Grove. It can go off to the scrappers weighing a little more in the end. Attitudes were such that the standards of previous eras of tidiness around depots fell away completely and walking around could be hazardous. (Jerry Beddows)

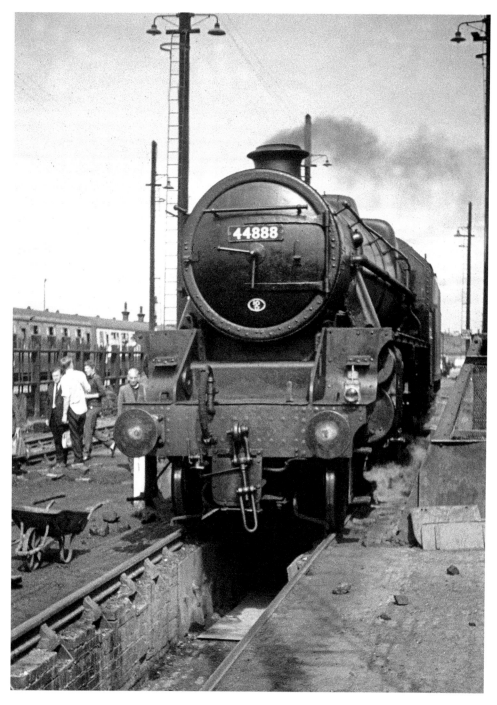

However, the same could not be said at Lostock Hall where Black Five No. 44888 was being serviced as the stock of an enthusiasts' special waited at the adjoining station platforms. Popular television shows at the time would include *Batman* starring Adam West, *The Monkees* and *Basil Brush* for younger viewers, while *Hawaii Five-O* brought glamour and excitement to the small screen for grown ups. Making its BBC debut during 1968 was *Dad's Army*. At first in black and white, it would go on to become one of the nation's favourites. (Len Smith)

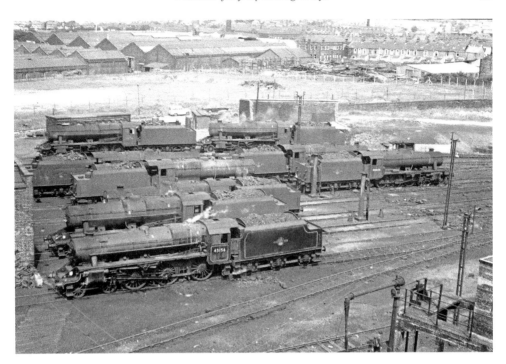

Stanier 2-8-0 Class 8Fs dominate this view from the coaler at Rose Grove on a sunnier visit on 21 July. Surging to number one in the charts for just the one week thankfully, according to the jokes of Morecambe and Wise, would be Des O'Connor with 'I Pretend'. (Jerry Beddows)

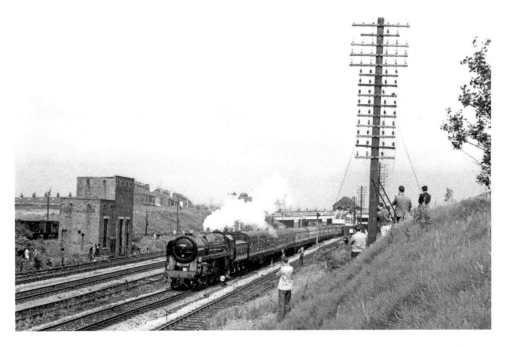

Sharing the special with No. 44888 on 21 July would be No. 70013 *Oliver Cromwell*, being recorded here at Rose Grove by photographers. Also on duty this day for the train would be another Black Five, No. 45110, which would run the final leg from Southport Chapel Street to Manchester Central. (Jerry Beddows)

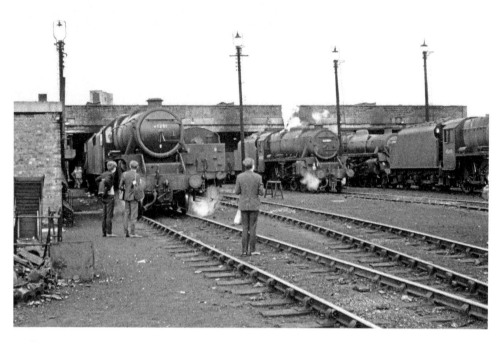

Duffle bags are the order of the day for younger spotters getting around Carnforth on 27 July 1968. (Strathwood Library Collection)

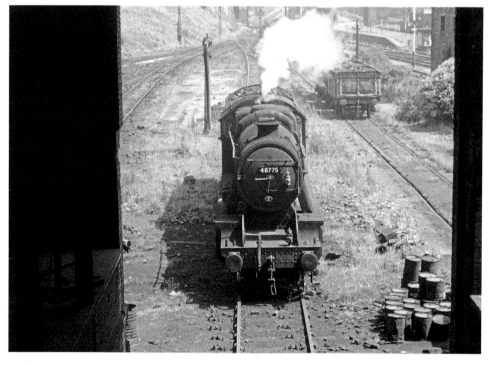

Making its way under the coaler and into the cool shade at Rose Grove is Class 8F 48775. (Jerry Beddows)

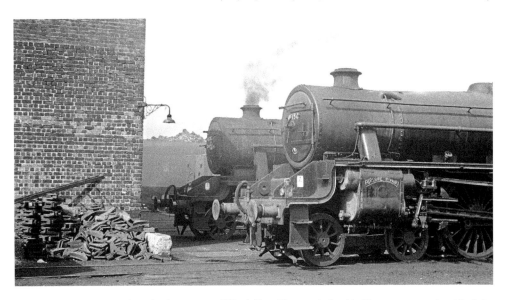

Chalked sentiments on the cylinder casing of Black Five No. 45156 *Ayrshire Yeomanry*, now devoid of the painted nameplates, standing alongside No. 48423, also in steam at Rose Grove. (Jerry Beddows)

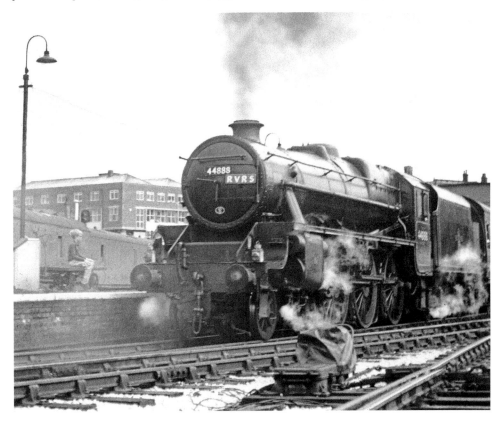

It seems unlikely that this young chap would be joining Black Five No. 44888 at Manchester Victoria for the first leg of the Roch Valley Railway Society tour on 21 July, which would include visits to both Rose Grove and Lostock Hall sheds. He would have to content himself with a seat on the platform trolley. (Jerry Beddows)

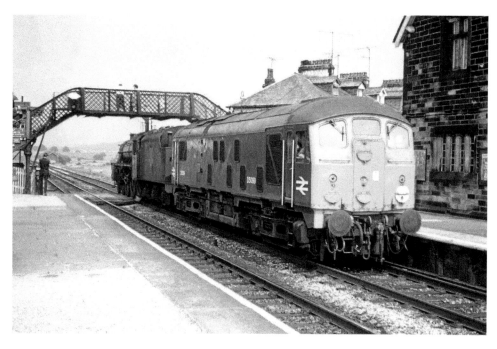

The first leg of a long road to Drapers Scrapyard in Hull from Carnforth for Black Five No. 45017, being hauled by Sulzer Type 2 D5xx through Hest Bank on 27 July. Only going as far as Lostock Hall today, the Stanier 4-6-0 would linger in the lines at 10D until April 1969 before the final journey to the mouth of the River Humber and the waiting oxyacetylene torches. (Strathwood Library Collection)

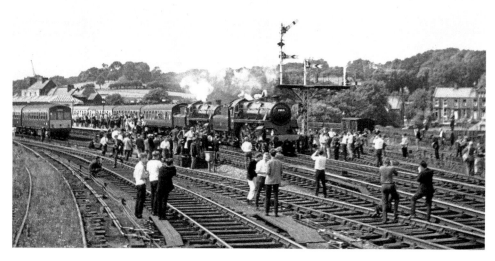

In anticipation of the final days, enthusiasts spill onto the track at Skipton on 28 July for the exchange of Standard 4MTs 75019 and 75027 for a Black Five pairing for the onward leg to Rose Grove, where Stanier 8F 48773 would be waiting. (Strathwood Library Collection)

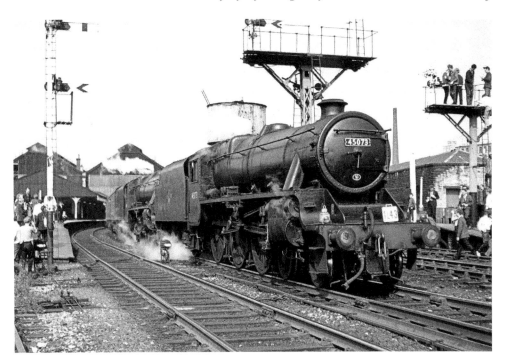

Our Black Five pairing of No. 45156 *Ayrshire Yeomanry* and No. 45073 with this next leg have paused at Blackburn, where spotters frantically try to gain vantage points to obtain their photographs. (Strathwood Library Collection)

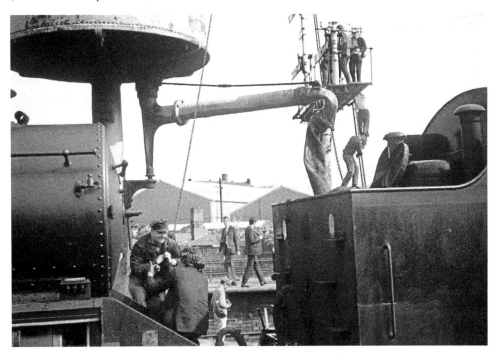

Enthusiasts scramble to record what they can on this Sunday afternoon at around four o'clock as the engines take on water. (Peter Coton)

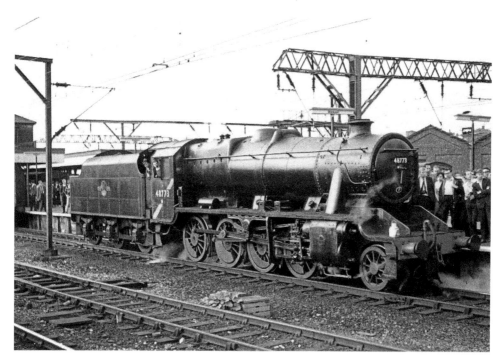

Having worked this Manchester Rail Travel Society / Severn Valley Railway Society Farewell to BR Steam special unassisted up Miles Platting bank and through Manchester Victoria, Stanier 8F 48773 comes off at Stockport to hand over to modern traction for the run back to New Street. (Strathwood Library Collection)

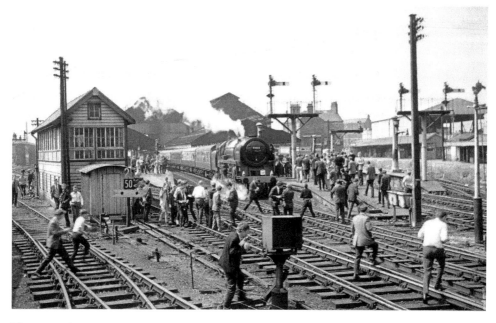

The outward run that morning had been behind Brush Type 4 D1906 from Birmingham, giving way to Britannia No. 70013 *Oliver Cromwell*, which took the back route from Stockport via Manchester Victoria – Tyldesley – Wigan North Western – Farington Jn – Hellifield – Wennington to Cornforth, where that pairing of Standard 4MTs seen at Skipton came on. (Strathwood Library Collection)

Early August

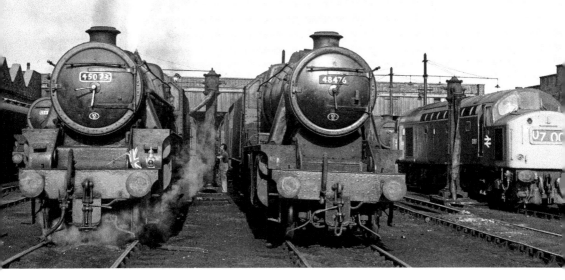

Water is being taken on shed by the crew of Black Five No. 45073 on 2 August 1968 while Stanier 8F 48476 sits quietly alongside a repainted Inter City blue English Electric Type 4. (Jerry Beddows)

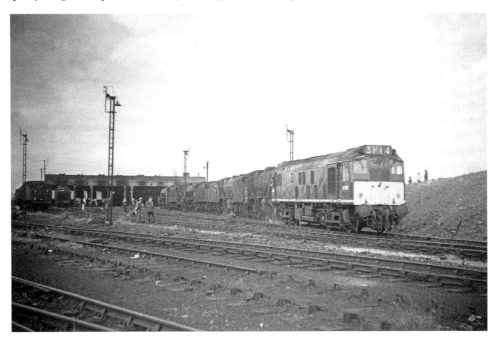

Trying to get three Stanier 8Fs, 48423, 48167 and 48730, as well as the once named No. 45156 devoid of the *Ayrshire Yeomanry* nameplates, moving in the shed yard at Rose Grove on 2 August was Sulzer Type 2 D5197, which was part of the D09 Manchester Division pool at the time. (Mick Farrer)

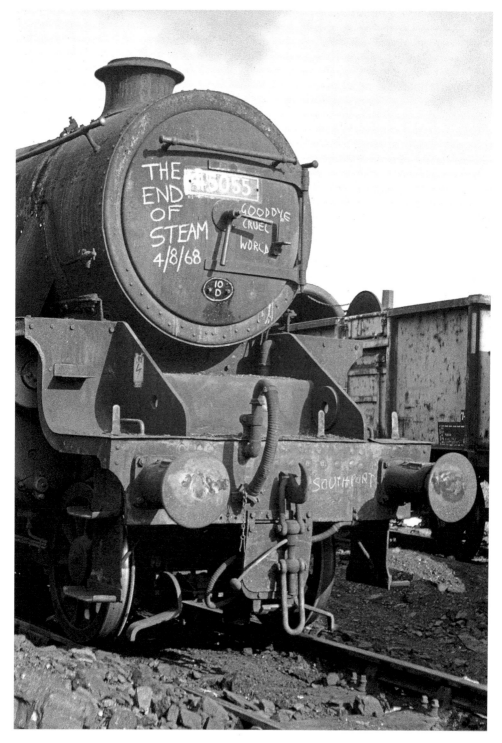

The cruel world would send this unfortunate Black Five from the storage roads at Lostock Hall, where we see it actually on 2 August, the following January to be devoured within Albert Draper's scrap yard at Hull during February 1969. (Jerry Beddows)

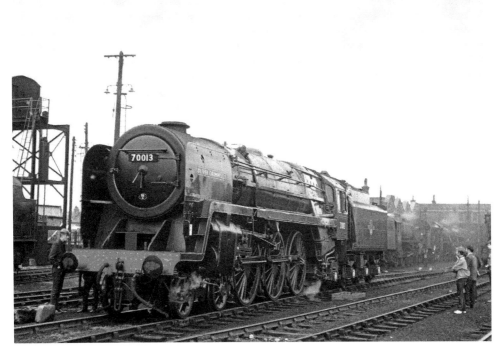

These lads at Lostock Hall are happy just to be able to watch the preparation of No. 70013 *Oliver Cromwell* for its role as part of the six end of steam specials to run the next day as the light fades on 3 August 1968. (Jerry Beddows)

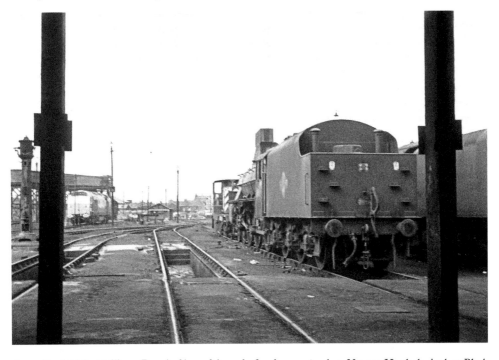

A new English Electric Type 4 D433 had been delivered a few days previously to Newton Heath shed, where Black Five No. 45202 stands among fallen comrades in front of the old shed buildings. (Strathwood Library Collection)

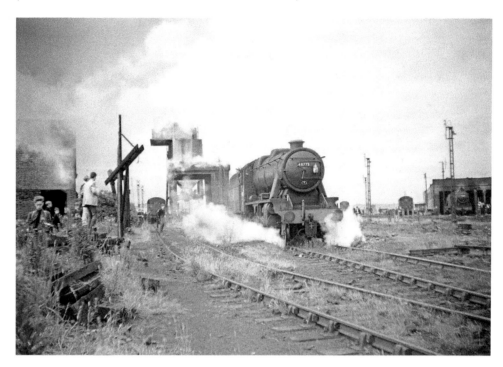

Following the every move of Class 8F 48773 around the shed yard at Rose Grove again on 3 August are an enthusiastic band of spotters, not wishing to miss a minute in these last moments of steam's career on our railways. If you had gone to the pictures that evening instead you may have had the choice of *The Good, the Bad and the Ugly*, *The Planet of the Apes* perhaps with Charlton Heston or even *The Italian Job*. (Both Photographs Mick Farrer)

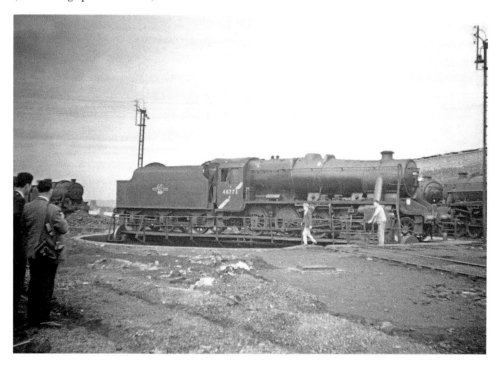

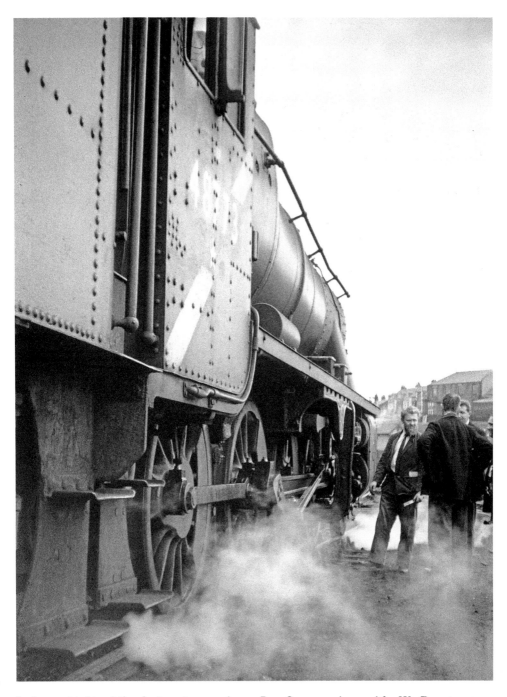

Let's stay with this privileged 2-8-0, 48773, seen here at Rose Grove on 3 August. After War Department use, she needed a new firebox by 1952 and was almost scrapped. With her repairs made, a move to Longmoor for five years followed. Becoming No. 48773 in 1957 on British Railways, her charmed existence continued, for she was subsequently withdrawn and reinstated twice. In 1966, No. 48773 had received a 'Heavy Intermediate' repair and overhauled boiler at Crewe Works. By July 1968, she had covered a modest 36,000 miles and as such was selected as the 8F in the best 'all round' condition, becoming the subject of a late and urgent appeal by the 8F Society and successful preservation. (Mick Farrer)

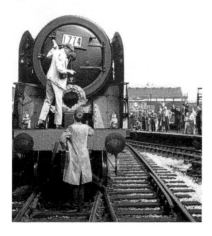

One of the engine crew for No. 70013 *Oliver Cromwell* at Manchester Victoria affixes a wreath to the smokebox of his engine, mindful no doubt of the safety of his camera, to record 4 August and the steam specials today. Coupled to a quickly spruced up Black Five, No. 44781, more enginemen go about the business of the day. (Strathwood Library Collection)

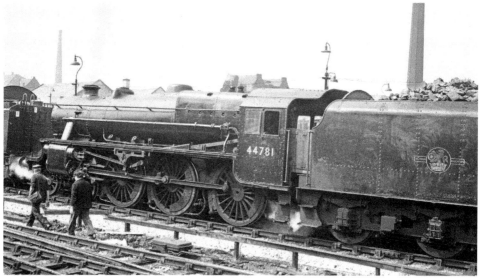

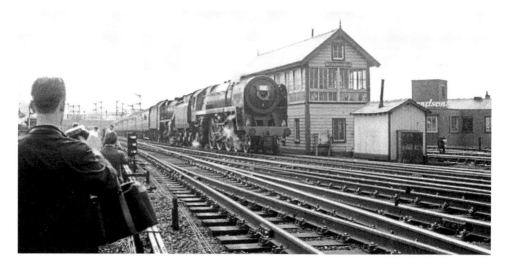

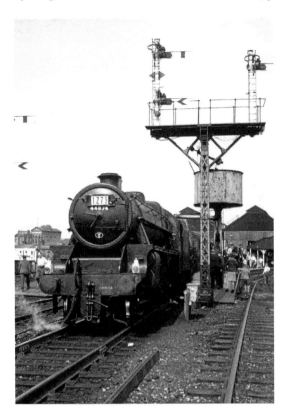

Crowds are along the trackside for the arrival of the pair at Blackburn with the first leg of the LCGB Farewell to Steam Railtour, where the Pacific was replaced by No. 48773.

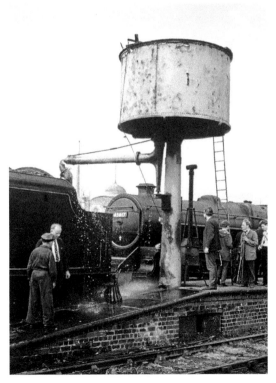

Demand was such that a Stephenson Locomotive Society (Midland Area) Farewell to Steam No. 2 special was run with Black Fives Nos 44874 and 45017, stopping for water at Blackburn. (Strathwood Library Collection)

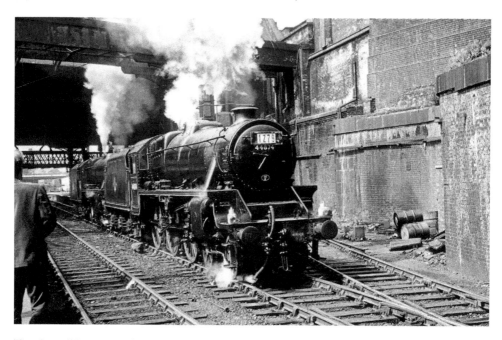

This duet of Nos 44874 and 45017 are seen again at Manchester Victoria among the crowds on the platform, some of whom are unable to travel as all tickets had been sold on all of the trains in advance. The route for this pairing was Manchester Victoria – Diggle – Huddersfield – Sowerby Bridge – Copy Pit – Blackburn – (via Bolton avoiding line) – Wigan Wallgate – Kirkby – Bootle – Stanley – Rainhill – Barton Moss – Manchester Victoria – Droylesden – Stockport, handing back to a WCML electric locomotive for the run back to New Street well behind time. (Strathwood Library Collection and Dave Livesey)

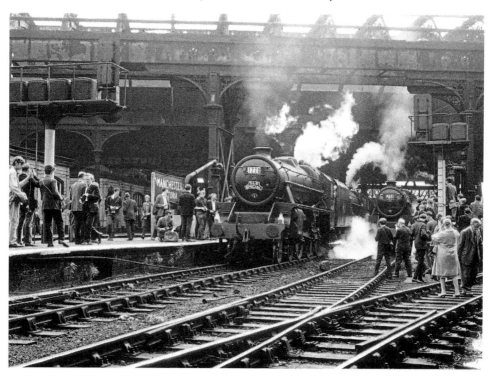

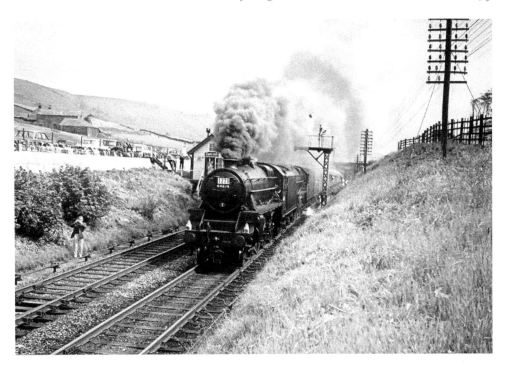

Meanwhile, the other train arranged by the Stephenson Locomotive Society (Midland Area) as their Farewell to Steam No. 1, behind Black Fives Nos 44894 and 44871, was also greeted by crowds of onlookers as they tore through Copy Pit. The other pair on the Stephenson Locomotive Society No. 2 special are picked up again running past an almost silent shed yard at Rose Grove West. (Both Photographs Strathwood Library Collection)

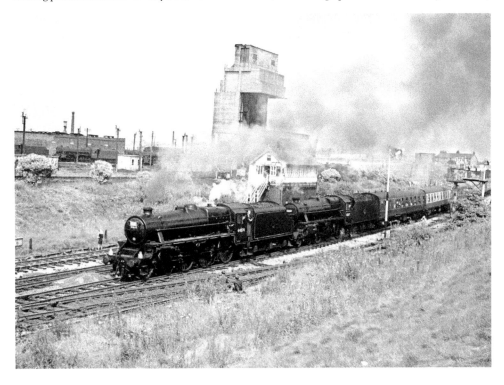

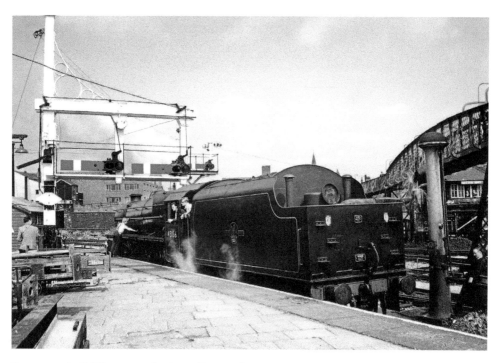

Running as the GC Enterprises Stockport (Bahamas) Locomotive Society Farewell to Steam Tour, which ran from Stockport to Carnforth and back behind Black Five No. 45156; the erstwhile *Ayrshire Yeomanry* is seen here at Bolton awaiting some action. (Chris Forrest)

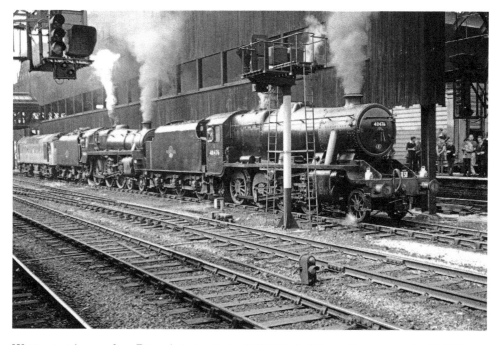

Waiting to take over from D1624, bringing in the RCTS End of Steam Commemorative Rail Tour at Manchester Victoria on this last regular weekend of steam, are Stanier 8F 48476 and Standard 5MT 73069. This tour will be a real event as we shall see. (Strathwood Library Collection)

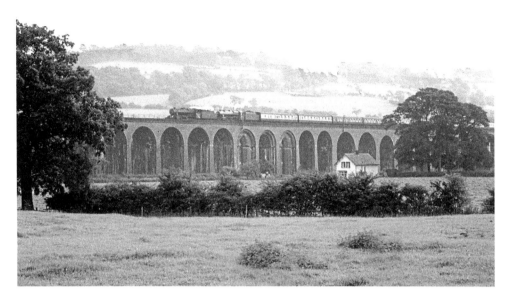

The LCGB Farewell to Steam Railtour behind Nos 48773 and 44781 continued with a run to Carnforth, seen here crossing Whalley Arches, before heading south again behind Black Fives Nos 45390 and 45025 via Hellifield – Blackburn – Lostock Hall, where English Electric Type 4 D416 carried on as far as Crewe. What should have been an on-time run back down the WCML into Euston was made 131 minutes down. (Strathwood Library Collection)

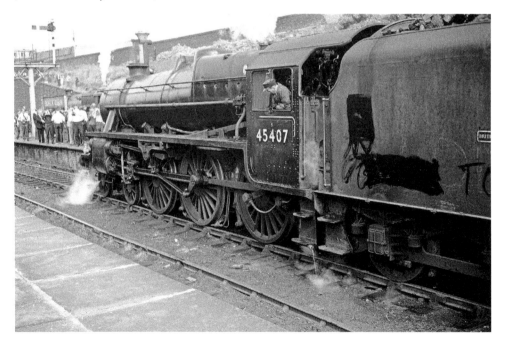

During the day at Blackburn, No. 45407 would be waiting to take over from No. 48476, scheduled to be taken off the RCTS train with the Black then to be paired with No. 73069. However, things were going wrong everywhere. (Strathwood Library Collection)

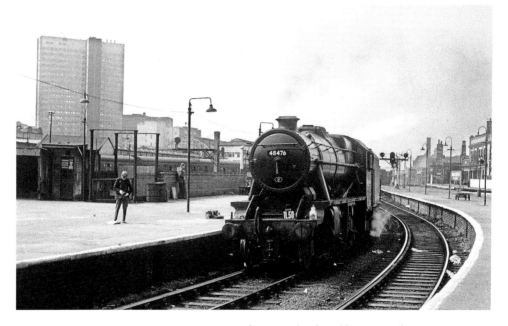

A spotter takes down Nos 48476 and 73069 at Manchester Victoria earlier in the day. Of the six railtours run alongside each other on 4 August, this train suffered the worse with delays; it being a Sunday did not help matters. The three-hour schedule to Stockport from London was exceeded by 71 minutes, caused by a whole variety of operating problems. In changing locomotives at Manchester Victoria the lateness increased to 90 minutes. A false track indication on the line to Oldham caused further delays, Oldham being reached 120 minutes down. Further wrong line working and an alleged leaking tender on the 8F, requiring a water stop, brought the lateness to 170 minutes at Blackburn. The locomotive change here over-ran the allotted time and a train sent ahead of the tour induced further delays caused by the long Sunday block sections. Arrival at Hellifield was now 225 minutes late and with it came decision time. The tour was intended to visit Liverpool Docks and traverse the historic Liverpool–Manchester line. The decision was made to curtail the tour as by the time of the last steam locomotive change at Lostock Hall, the tour was over 240 minutes late! Over thirty minutes was lost at Manchester Victoria whilst attempts were made (unsuccessfully) to water the dining car. Lateness here had actually been reduced to 210 minutes because of the curtailment of the planned route. A watering stop of thirty minutes was made at Crewe; however the wrong vehicle was initially watered! The delays encountered on the ride north on the WCML that morning were still well and truly in evidence, with final arrival at Euston being some 270 minutes late. (Both Photographs Stathwood library Collection)

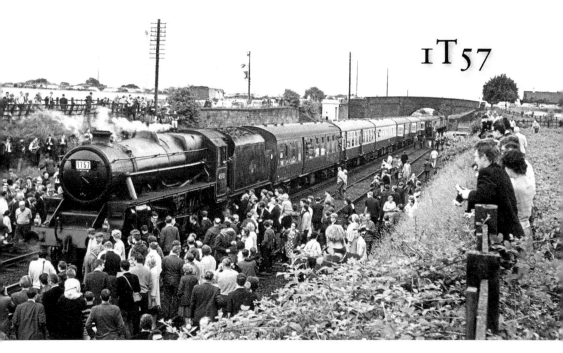

This 315-mile, almost eleven-hour journey marked the end of standard gauge steam-hauled passenger service on British Railways. 1T57: the last steam-hauled train on British Railways on standard gauge track, Sunday 11 August 1968. It was entrusted firstly to Black Five No. 45110, which set off from Liverpool Lime Street on time at 09.10, arriving 4 minutes down at Rainhill, in front of the Huskisson Memorial appropriately on this day of days. (Late Alan Marriott/Strathwood Library Collection)

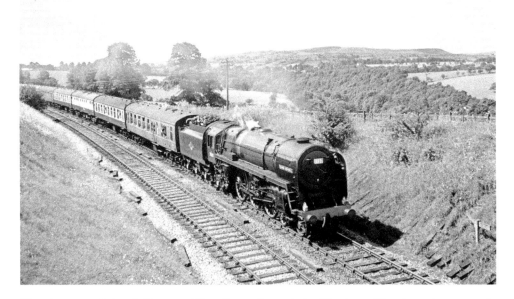

Changing over to Britannia No. 70013 *Oliver Cromwell* on arrival at Manchester Victoria, getting away again on time at 11.06, we pick it up at Gisburn. Arrival at Blackburn 1 minute up to leave 28 minutes down would mean some changes along the route, and folk before the age of mobile telephones thinking the worst on the lineside. (Jack Hodgkinson)

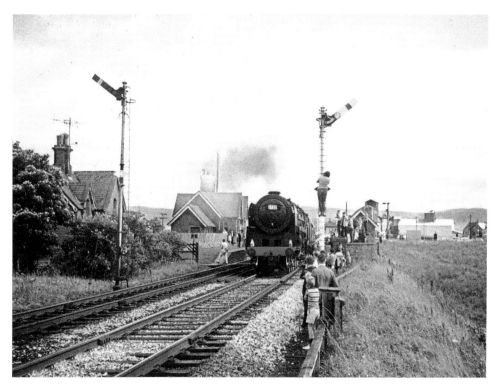

All along the route all the generations who could make it to the lineside did so, as here at Ribblehead, which in a modern world would be unthinkable sadly. (Both Photographs Richard Sinclair Collection)

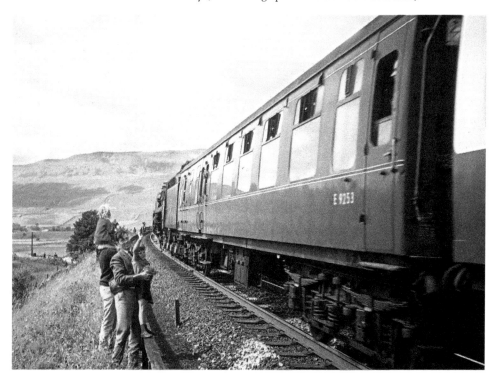

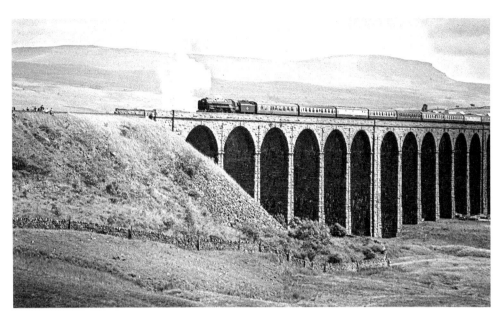

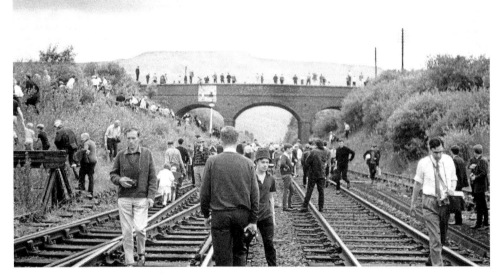

The hillsides at Ribblehead were nothing
in comparison to those at Ais Gill where a
stop was planned from 13.45–14.05, which
became in reality 14.20–14.33. It should also
be recalled that service trains were being
routed from the WCML along the Settle
and Carlisle this Sunday due to engineering
works, although drivers would know what to
possibly expect along the route fairly quickly
fortunately. (Photographs Strathwood Library
Collection, Jerry Beddows, Late Pete Walton/
Sid Steadman)

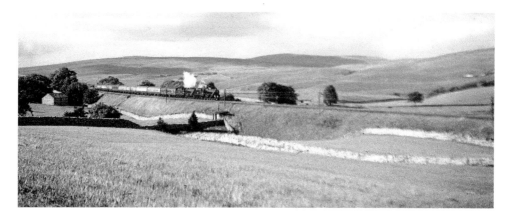

Most interest seems to have been in the outward run rather than the return with Black Fives Nos 44871 and 44781, passing Horton in Ribblesdale around teatime. (Ian King)

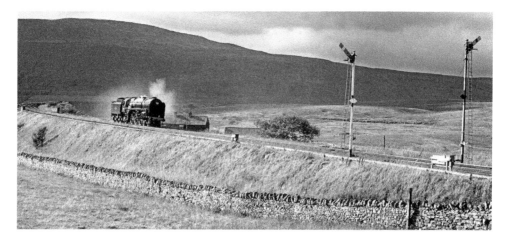

Some diehards hung around and caught No. 70013 *Oliver Cromwell* making its way south light engine, bound for Bressingham, following the Black Fives a little later. (Jerry Beddows)

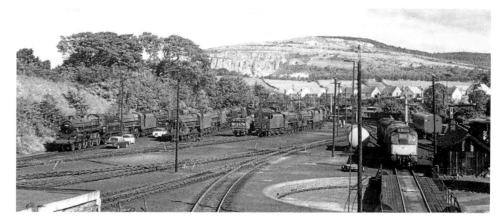

Some would even visit Carnforth depot to have a last look around. Now all was silent save for a few diesels and the birdsong. This is the view of the north yard from the footbridge. (Jerry Beddows)

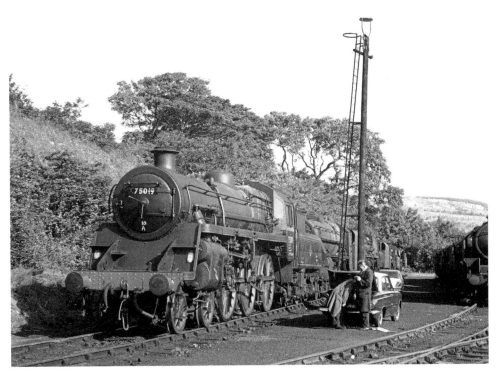

Oh! before a run back down the A6 one last shot of Standard 4MT 75019 standing cold at Carnforth on 11 August 1968. (Jerry Beddows)

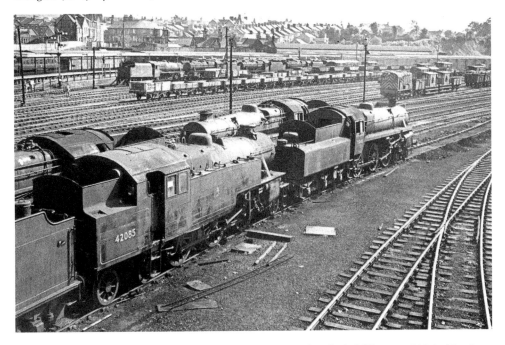

Fairburn 4MT 42085 had been secured for preservation; however Standard 4MT 75048, which had just been withdrawn days before and dumped at Carnforth, would be doomed and a journey north to Campbell's in Airdrie would be forthcoming in November. (Strathwood Library Collection)

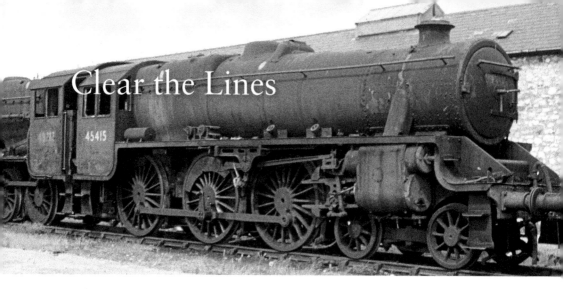

Clear the Lines

Many cameramen gave up and did not venture out to record the grisly scrap yard views at the end of that last summer and on through the following winter and spring, views such as here with Black Five No. 45415 from 9K (Bolton) about to be chopped at Cashmores in Newport on 18 August 1968.

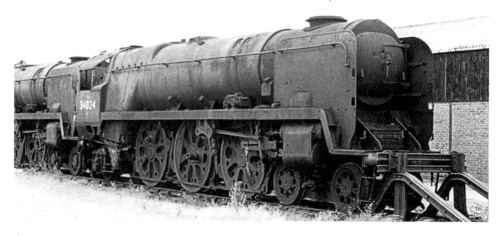

As we saw at the beginning of this volume in the Sixties Spotting Days series, the Southern Region was a year on from its own last day of steam and still disposing of locomotives from the dumps, as with this pair of Bulleid Pacifics in Buttiegeigs yard at Newport the same weekend.

A good number of engines would perish here at this time, as men worked to clear this last glut of steam locomotives offered for sale. (All Photographs Strathwood Library Collection)

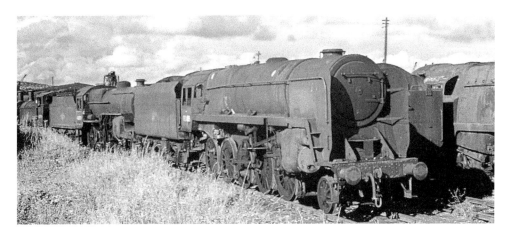

Unable to let go and leading the way that so many would follow in the next few years, some cameramen made trips to witness the spectacle that was Barry Scrapyard. Arriving from Birkenhead in June 1967, Class 9F 92085 would spend thirteen years within Woodhams yard, sadly to be denied preservation and cut up in 1980. Visitors on 18 August 1968 would have never believed how many other locomotives would be saved over the next twenty years from those they saw that day. (Jerry Beddows)

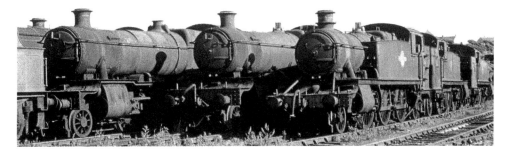

Having been withdrawn from service some years before from the Western Region, Woodhams yard would play a valuable holding role from many ex-Great Western Railway designs that would otherwise have vanished three or four years previously, such as these lined up rusting away the same day in the salty sea air. (Strathwood Library Collection)

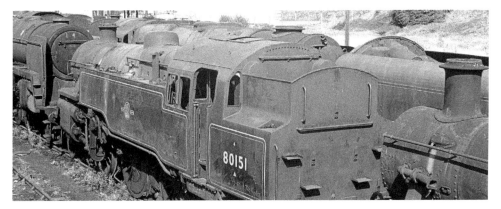

Arriving at Barry at the beginning of 1968 was Standard 4MT 80151. Although it had lost its motion, it still looked in reasonable condition this first weekend after the end of steam. It would take until March 1975 for the funds to be available to remove the engine for preservation. (Jerry Beddows)

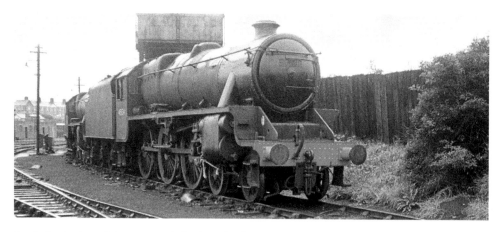

At the beginning of the next week, back at the former steam sheds in the North West, scrap dealers were making their tenders for locomotives such as Black Five No. 45134 at Carnforth on 19 August 1968. (Strathwood Library Collection)

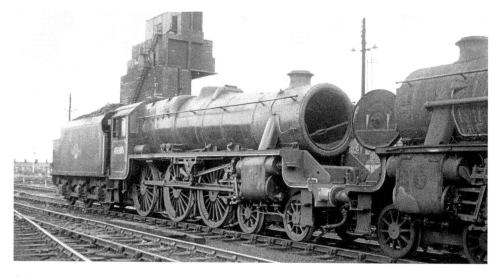

Others were purchased by preservation groups such as Black Five No. 45305 at Lostock Hall on 20 August 1968, bought by the North Eastern Locomotive Preservation Group. (Strathwood Library Collection)

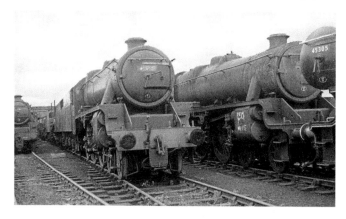

The Severn Valley Railway would provide a new home for another Black Five, No. 45110, also at Lostock Hall that same day, although it would not go south until January 1969. (Strathwood Library Collection)

Still among the lines weeks after we first saw it at Lostock Hall was yet another, No. 45212, which would join the fleet at the Keighley and Worth Valley Railway before the end of August. (Chris Forrest)

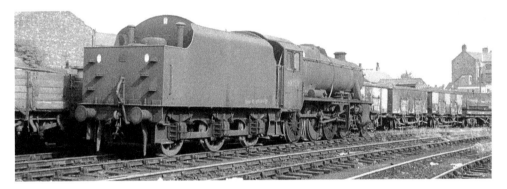

The path to Wards of Beighton for Stanier 8F 48752 would be delayed at Springs Branch from 21 August 1968 until February 1969. (Strathwood Library Collection)

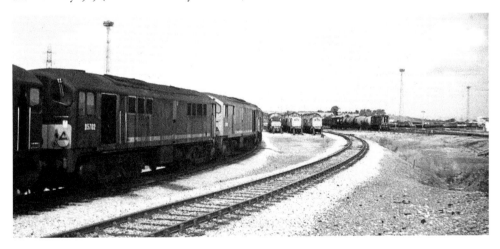

A number of diesel types would make their farewells this year, including some of the Metropolitan Vickers Co-Bo design such as D5702, seen with a few classmates here at Carlisle Kingmoor New Yard in 1968. Many of the Clayton Type 1s in the background, although less than six years old, would make their demise too. (Neil Snuggs)

Preservation Carries Us Forward

Taking a family holiday that summer to experience some steam, you might have tried the Great Little Trains of Wales, such as here at Towyn on the Tallylyn Railway. (Chris Forrest)

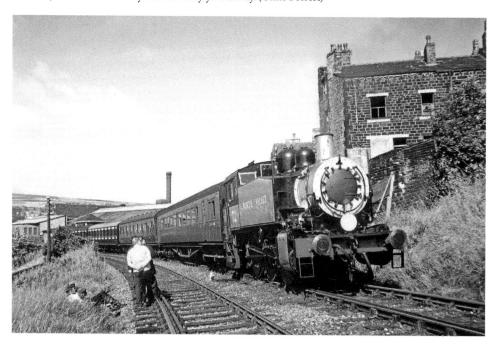

Alternatively, a day out in the sunshine on the Keighley and Worth Valley Railway where the volunteers around ex-USA Class No. 30072 appear pretty relaxed on the lineside a week after the end of British Rail steam. (Chris Forrest)

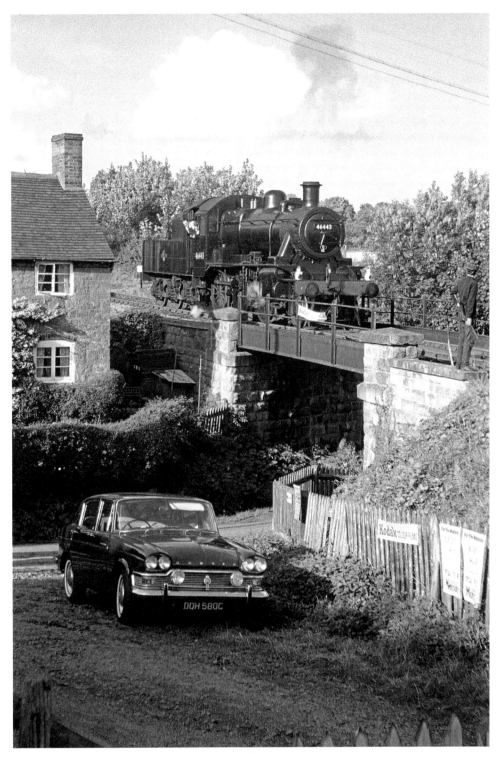

A flagman is in operation at Hampton Loade on the Severn Valley Railway while the footplate crew of Ivatt 2MT 46443 look out as they shunt on past a rather splendid Humber with period whitewall tyres. (Jerry Beddows)

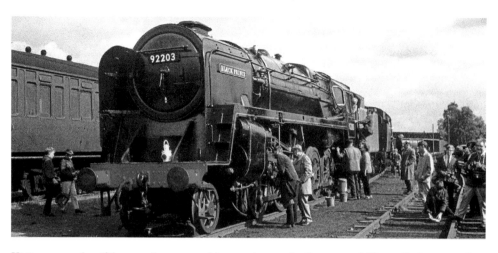

Visitors were plentiful to see the preserved locomotives at the Longmoor Military Railway near Liss in September 1968. Both of the renowned artist David Shepherd's engines, Standard 4MT 75029 and his Class 9F 92203, were here, now carrying names *The Green Knight* and *Black Prince* respectively.

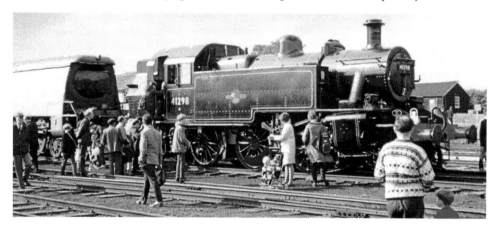

Also resident at this time was Ivatt 2MT, which had survived until the end of Southern Region steam in July 1967. Bulleid Pacifics No. 34023 *Blackmore Vale* along with No. 35028 *Clan Line* also found a temporary home here, until the railway closed on 31 October 1969. (All Strathwood Library Collection)

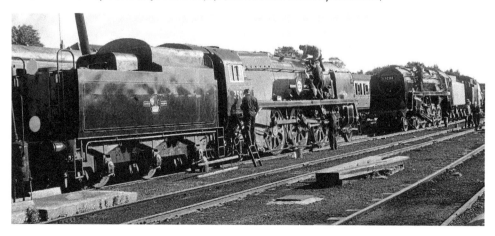

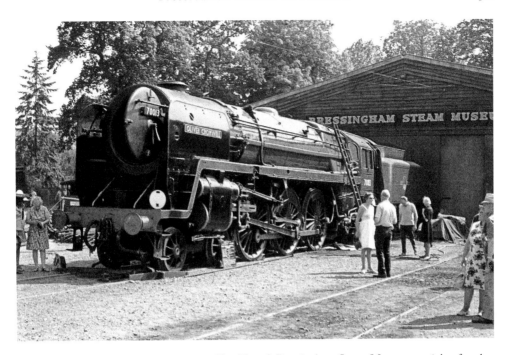

A home was made for over twenty years at Alan Bloom's Bressingham Steam Museum, straight after that very last Fifteen Guinea Last Steam Special 1T57, for Britannia No. 70013 *Oliver Cromwell*. The engine did make a stop for servicing at Lostock Hall and was taken on to this new home crewed by Healey Mills men. (Trans Pennine Publishing)

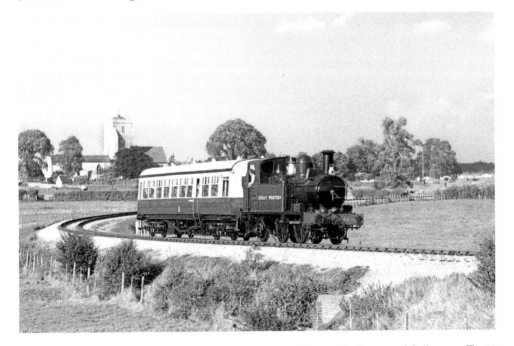

The ever energetic Great Western Society arranged on 21 September 1968 for the restored Collett 0-4-2T 1466 to make runs along the branch back from Wallingford to the mainline at Cholsey. The station at Wallingford had been closed to passenger since 1959. (Aldo Delicata)

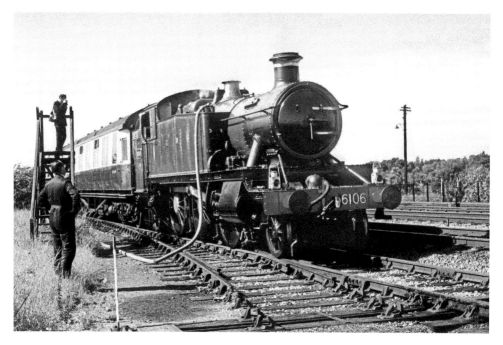

Although the Great Western Society occupied the former engine sheds at Didcot, some of the facilities back in 1968 were far more basic than those enjoyed today. The sole surviving 6100 Class large Prairie, 6106, gets a chance to run a round the yard limits with a Great Western Centenary coach in tow. (Bob Treacher/Alton Model Centre)

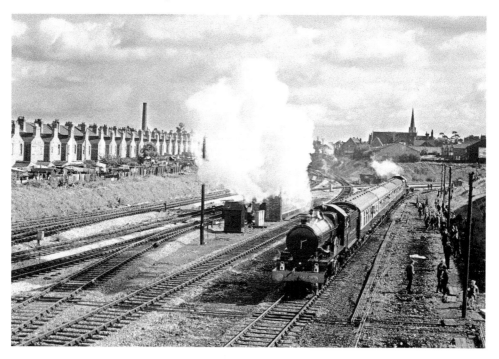

Tyseley Open Day on 29 September 1968 brought the chance for 7029 *Clun Castle* to top and tail with 5593 *Kolhapur* for the entertainment of visitors. (Jerry Beddows)

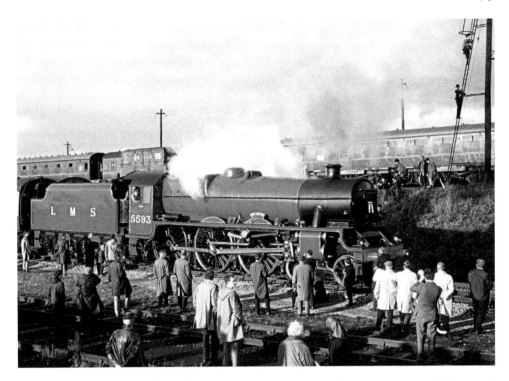

The preserved Jubilee looked a fine sight in steam once again in the sunshine as many wondered if they would ever see its like on the mainline again. (John Gill)

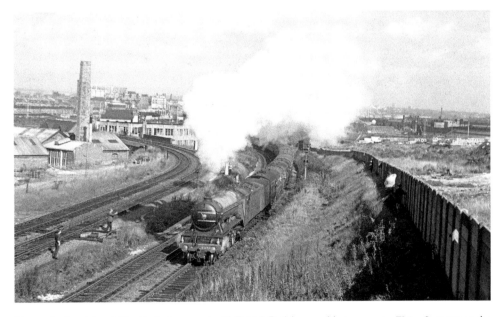

Due to the foresight of Alan Pegler's contract with British Rail, he was able to run 4472 *Flying Scotsman* on the mainline while all others were banned after No. 70013 had arrived at Bressingham the month before. Bringing more visitors to the Open Day and passing St Andrews Junction on 29 September was this epic locomotive, which would later travel to the USA and then in new ownership visit Australia twenty years later. (Jerry Beddows)

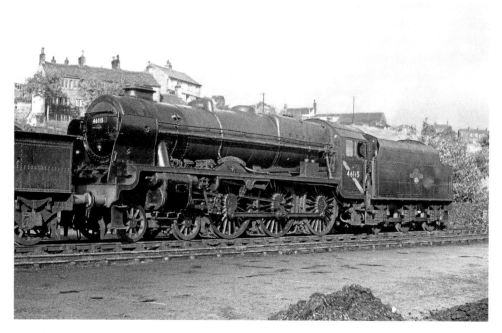

Outside in the yard at Howarth, the outward appearance of Royal Scot No. 46115 *Scots Guardsman* on 29 September 1968 was still very good almost three years after the engine's last runs in service. Forty years later it would be invited to return to the Keighley and Worth Valley Railway in their 40th Anniversary Year. (Strathwood Library Collection)

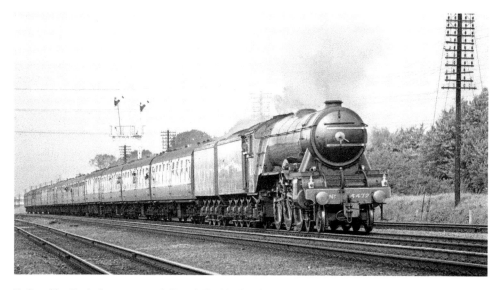

Before Alan Pegler's contract with British Rail had ended, he hit upon the idea of taking *Flying Scotsman* to the USA to pull an exhibition train. So in 1969, 4472, complete with its two tenders, left the UK to tour the North American continent, visiting major cities as well as small towns. The tour started well but by 1972 financial problems led to disaster and bankruptcy. Just in time a new owner, Sir William McAlpine, came forward to rescue *Flying Scotsman*. The locomotive was successfully repatriated in February 1973, to the relief of so many. Among the last few main line runs undertaken in 1968 was this special for an the Clapham Open Day on 20 October, seen passing Marshmoor. (Aldo Delicata)

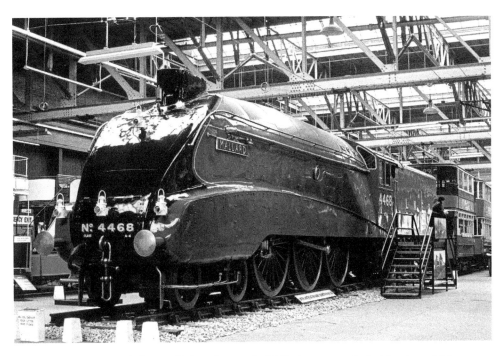

That other London North Eastern Railway icon, 4468 *Mallard*, was entombed with other exhibits as part of the National Collection inside the former London County Council tram depot at Clapham along with a fine selection of London trams and buses. Would any of these visitors to the museum ever think a brand new Pacific such as No. 60163 *Tornado*, whose parentage could be traced back to both *Mallard* and *Flying Scotsman* would be built forty years after the end of steam on British Rail in 1968, and what's more like so many preserved steam locomotives it would make almost regular runs for the public again on our main lines? Long may it continue. (Photographs Strathwood Library Collection and Frank Hornby)

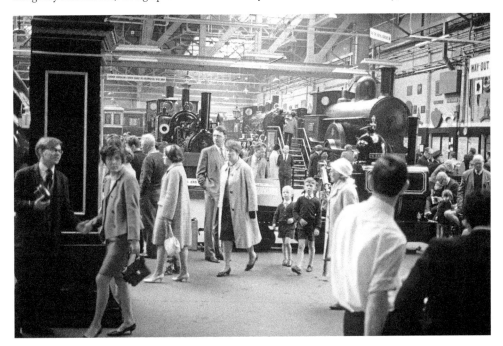